THE

JASON
ROHRER

THE GAME WORLDS OF JASON ROHRER

by Michael Maizels and Patrick Jagoda

Distributed by the MIT Press
Cambridge, Massachusetts
London, England

Published in conjunction with the exhibition
The Game Worlds of Jason Rohrer
February 10–June 26, 2016
Curated by Michael Maizels, Mellon New Media Art Curator/Lecturer

This exhibition and catalogue are made possible with generous support
from The Andrew W. Mellon Foundation.

Jason Rohrer's "Beyond Our Grasp" was first published in *PC Gamer*, no. 205
(October 2010): 26.

Screen captures: Anthony Montuori and Joshua Collins
Catalogue design: Stoltze Design
Editing: Lucy Flint
Printing: Puritan Capital, Inc.

MIT Press books may be purchased at special quantity discounts for business
or sales promotional use.

This book was set in Unibody 8 Pro, Input Mono, and Swiss 721, and was printed and
bound in the United States of America.

Library of Congress Cataloging-in-Publication Data is available.

ISBN: 978-0-262-52911-2

Alibris DB-EW

the Davis.
DAVIS MUSEUM AT WELLESLEY COLLEGE

Davis Museum
Wellesley College
106 Central Street
Wellesley, Massachusetts 02481
www.thedavis.org

TABLE OF CONTENTS

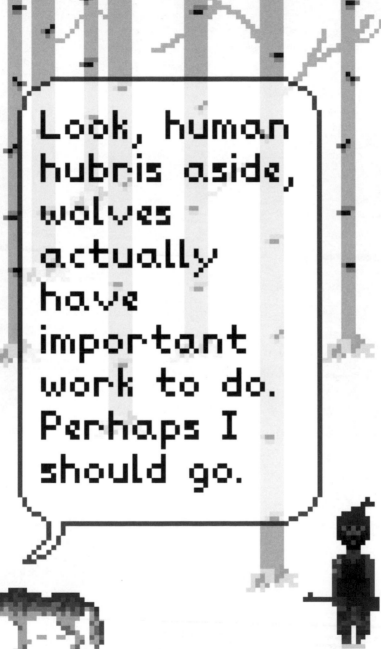

Still from *Sleep Is Death (Geisterfahrer)*

FOREWORD BY LISA FISCHMAN
Ruth Gordon Shapiro '37 Director

It is my privilege to introduce *The Game Worlds of Jason Rohrer*, which marks a milestone for the Davis Museum at Wellesley College and for the field of new media art: at a time when museums increasingly strive to engage with videogames, this exhibition is the first to examine in monographic depth the *oeuvre* of an individual maker. The project offers multifold pleasures as an in-depth introduction to the nuanced intelligence and pictorial elegance of Jason Rohrer. This comprehensive exploration of his eclectic body of games—their multivalent ideas, complex referential syntax, coding processes, and eloquent execution—continually complicates received expectations.

In the galleries and in print, *The Game Worlds of Jason Rohrer* represents a labyrinthine journey toward the goal of interrogating a new medium through a new museological apparatus. Devised through the games themselves rather than imposed upon them, the approach is designed to expand our sense of what gameplay can allow.

As Jason Rohrer says so memorably in the interview printed here: "Where linear, fully authored works may leave room for interpretation on the part of the audience, videogames almost always leave room for *completion* on the part of the audience. The inputs and choices made by the players are the final missing ingredients that are necessary for any game to realize its full potential. Without the player the game is inert." Part of the Davis's ambitious venture on this front has been to consider how the museum can function as a platform for playing together, and to enact the process of making space—philosophically, logistically, and by design—for gaming and acts of completion as gestures with intellectual weight and aesthetic merit.

Michael Maizels, curator of the exhibition, brought considerable expertise, inspired commitment, and tenacious enthusiasm to this project's development and realization. Its far-ranging scope and grand success represent the culmination of his appointment as the Mellon New Media Art Curator/Lecturer, a three-year position shared by the Davis Museum and the Art Department at Wellesley, and only hint at his impact on campus.

My thanks to Mike, and to Patrick Jagoda, for their astute scholarly contributions to this volume; to Jason Rohrer for his smart interview; and to Joshua Collins, who adds his distinctive voice as a high-scorer. Clif Stoltze, Katherine Hughes, and Prin Limphongpand of Stoltze Design are responsible for this absolutely stunning catalogue. Thanks to Anthony Montuori for the sharp screen grabs. Thanks beyond measure to Lucy Flint for her essential editorial prowess. My thanks to Yugon Kim and Tomomi Itakura of ikd in Cambridge, Massachusetts, for their spectacular installation design, beautifully efficient in its material and formal properties.

The Davis staff, as ever, comes together behind every major exhibition project. In this instance, I would like to recognize particularly Eve Straussman-Pflanzer, Assistant Director of Curatorial Affairs/Senior Curator of Collections; Mark Beeman, Manager of Exhibitions and Collections Preparation; Helen Connor, Assistant Registrar/Documentation Specialist; Liz Gardner, Public and Interpretive Programs Specialist; Tsugumi Joiner, Associate Director of Operations and Collections Management; Sarina Khan-Reddy, Media Specialist; and Craig Uram, Assistant Preparator/Collections Care Specialist, for their invaluable work. In preparation, students in the 2015 class of the Davis Museum Summer Internship Program played Jason Rohrer's games and plotted instructions for gallery visitors. Ningyi Xi and Carrington Obrion were especially helpful.

The Game Worlds of Jason Rohrer represents the pinnacle of an aspirational leap sparked in the New York offices of Mariët Westermann, Vice President of the Art History, Conservation, and Museums Program at The Andrew W. Mellon Foundation. With her support, the generosity of the Mellon Foundation has allowed the Davis to explore and experiment, curatorially and pedagogically; to blur lines and refocus museologically on new media art in ways that would simply otherwise not have been possible.

As ever, I am grateful to H. Kim Bottomly, President of Wellesley College, and to Andrew Shennan, Provost and Dean of the College, for their unwavering support of the Davis.

CURATING PLAY, OR GAMES FOR A MUSEUM BY MICHAEL MAIZELS

Mellon New Media Art Curator/Lecturer

"Passage must be effected from the white page
and the blank canvas . . . to a place where life, all of it, is *play*"[1]

VINCENT KAUFMANN (1997)

Jason Rohrer's visually elegant and conceptually intricate games have made him one of the most widely heralded independent videogame designers in the brief history of the field. Drawing on his training in literature, music, and computer science, Rohrer's games tell stories—rendered in a signature, highly pixelated style—that address complex subjects such as mortality, melancholy, deception, and the nature of infinity. Their ingenuity and affective power have helped move gaming and play into the realm of art.[2]

Rohrer's ascendance into the national spotlight began with *Passage*, 2007 (page 26), a scrolling game set within a narrow space of only 256 pixels in which users control an avatar modeled on Rohrer himself, whom they may pair up with a female character along the way. As the protagonist wends his way forward, he starts to age. First, his blond hair turns brown, then gray, and ultimately falls out. He grows stooped and slow, and, after a mere five minutes, the game simply ends. While the emotional impact of this fatalistic game spread Rohrer's fame through the buzz of Internet chat rooms, his place in the pantheon of independent game designers was cemented by subsequent prize-winning games such as *Chain World,* 2011—a Garden of Eden–style game of which only one copy was ever produced—and *A Game for Someone*, 2013, a post-apocalyptic take on a board game that he buried in an unknown desert location.

In 2012, Rohrer became one of the few independent designers to have their videogames acquired by the Museum of Modern Art in New York. Following on this milestone, the 2015 *The Game Worlds of Jason Rohrer* at the Davis represents the first major monographic museum retrospective devoted to a single videogame maker. Though this is a noteworthy event in the history of the medium, the exhibition forms part of a larger set of investigations by curators and scholars working to establish the videogame as a form worthy of serious consideration. Beginning with Beryl Graham's exhibition *Serious Games* (1996–97), videogames have been gaining attention in the art world for the

past two decades.³ This attention has produced compelling solo projects by artists including Cory Arcangel, Mary Flanagan, and Eddo Stern, as well as large survey exhibitions, such as media art theorist Tilman Baumgärtel's *Video Games by Artists* at the Hartware Medien Kunst Verein, Dortmund-Hörde, Germany, in 2003, and *The Art of Video Games* at the Smithsonian American Art Museum in Washington, D.C., in 2012.⁴

The Game Worlds of Jason Rohrer takes the next curatorial and historical step. Its predecessors have helped establish that videogames can be understood and interrogated as art. Now, the work of a game designer is used to both illuminate and challenge the conceptual underpinnings of that loaded term. The exhibition and this catalogue form a case study in which the terms "game" and "art" can each be allowed to complicate and nuance an understanding of the other. How might the characteristic fabric of the videogame—something nonlinear, dynamic, and participatory—open up the traditional museum experience? How might a videogame exhibition connect the visitor to an original function of the museum—the display of objects of material culture that were not designed for spaces of aesthetic display? The contributors to this project broach new ways of approaching the videogame format and consider afresh the ways in which a museum exhibition might encourage the view that games can comprise an artist's *oeuvre*.

This last question—which concerns the ways that authorship and creativity have been construed in different contexts—is critical, not simply for unpacking Rohrer's games, but also for understanding a historical contradiction that lies at the heart of what we term "new media art." Our current understanding of art itself traces its roots back to the Renaissance, when humanism placed a new emphasis on the creative individual.⁵ Unlike the masters of the Middle Ages, who dedicated their anonymous labors to God, many Renaissance painters and sculptors were valued by a new group of patrons as individual makers—creators with uniquely defined virtuosity and vision. Through successive centuries, the so-called cult of the maker/author continued to gather strength, reaching its apogee in the

nineteenth century, when the absolute singularity of the artist—the romantic genius—trumped all other aesthetic concerns.

Through the course of twentieth century, however, this humanistic model began to erode. Thinkers such as Roland Barthes and Michel Foucault leveled sustained, articulate assaults on the assumptions that underpin what remains today a widely held set of beliefs concerning the nature and meaning of creative authorship.⁶ For these thinkers, the notion of an individual artist expressing a coherent, meaningful vision of the world through art was an interpretive fiction. Rather, it was critics, historians, and curators who retroactively imposed a single "author" on a body of disconnected work produced in response to an array of psychological, social, and technological forces. Not coincidentally, this same moment saw a different group of thinkers argue that the importance of the individual subject had been obviated by a rapidly proliferating and increasingly powerful set of technologies. For the mid-century proponents of ideas ranging from cybernetics to systems theory, it was not the individual as such that mattered.⁷ Rather, explanatory power lay within a larger socio-technical network—of which an individual could only ever form an insignificant, and largely interchangeable, part.

Much as Renaissance humanism was the ferment out of which grew our received understanding of "the artist," the mid-century rise of systems thinking forms the intellectual backdrop for what we term "new media."⁸ As a mode of practice, new media work is rarely composed by single creators, and does not typically find its expression in the freestanding, historically durable objects that up to the twentieth century defined art. Instead, new media practice foregrounds ways of making that are exploratory, collaborative, and ephemeral. Although this method of working applies to a wide swath of contemporary makers, it finds a particularly clear illustration in Douglas Davis, who in 1995 conceived the website *The World's First Collaborative Sentence* as a literary text "authored" by widely dispersed contributors.

The uneasy juxtaposition of the human and the beyond-human is central to Rohrer's

production. On the one hand, his games are the product of a singular artistic vision, marked by a unique approach to visual, interactive, and sound design—all of which he does himself. Rohrer's work is in fact highly unusual, even in the independent videogame world, for being the product of his efforts alone. Moreover, many of his games grapple with intimately personal subjects—mortality in *Passage*, flights of creative inspiration and melancholy in *Gravitation*, 2008 (page 30)—that have also long persisted as leitmotifs in Western art.

However, other games by Rohrer are predicated on an attempt to push at the boundaries of the individual. For example, *Inside a Star-filled Sky*, 2011 (page 68), draws on classic maze and shooter games—think *Pac-Man* meets *Space Invaders*—but does so in a way that transcends the limits of human playability. The game is set inside what Rohrer describes as a "recursive labyrinth"—which grows to the scale of the known universe in level 14—and would take over 2,000 years of continuous play to "complete."[9] While *Inside a Star-filled Sky* ramifies in magnitude, a game such as *Sleep Is Death (Geisterfahrer)*, 2010 (page 62), destabilizes individual agency in other, more complicated ways. *Sleep Is Death (Geisterfahrer)* is comprised of an elementary stage set in which one player controls a protagonist and the second actively maintains the entirety of the environment.[10] Though the spare setting lends the game a sense of existential dread, the radically interdependent nature of its gameplay offers a mode of creation that is an equal-footed collaboration between players and makers.

As a zone of contact between the personal and the social (as well as the present and the timeless), the museum is an ideal setting in which to explore the worlds contained within games such as these. Visitors are encouraged to become players rather than viewers, and on entering the exhibition they may explore different modes of play—solo and multiplayer, adventure and puzzle—in the respective build-outs. Before entering the gallery space proper, visitors are invited via a wall-sized projection to play *Primrose*, 2009 (page 58), a deceptively simple puzzle-solving game that forms the visual centerpiece of the show. Players may collaboratively pit their skills against the infinite labyrinth of *Inside a Star-filled Sky*, displayed on an armature inspired by the nesting forms that structure the levels of the game. Or they may test their wits against other players in *Diamond Trust of London*, 2012 (page 72), a turn-based strategy game involving deception, loyalty, and manipulation, and *Cordial Minuet*, 2014 (page 84)—a game of numerical skill that examines the intertwined conceptual underpinnings of fortune-telling, gambling, and speculative capitalism that must be played for real money. All of these installations are designed to highlight the social dimension of gameplay: the thrill of discovery, or of victory, is deepened when it is shared.

The Game Worlds of Jason Rohrer foregrounds play as an active and transformative means of inquiry, and in doing so joins the effort of much avant-garde art of the last century to narrow the seemingly ever-widening gap between art and life. As the epigraph to this essay contends, creativity must move from the boundaries of conventional media to "a place where life, all of it, is *play*." This exhibition not only examines this possibility, but also explores its reversal, testing what can happen to life when play is situated in the spaces of art.

[1] Vincent Kaufmann, "Angels of Purity" *Guy Debord and the Situationist International: Texts and Documents,* ed. Tom McDonough (Cambridge, Mass.: MIT Press, 2004), 298.

[2] Rohrer has been credited by some with introducing the neologism "artgame," which he conceived as analogous to "art rock" or "art film." John Sharp, *Works of Game: On the Aesthetics of Games and Art* (Cambridge, Mass.: MIT Press, 2015), 15.

[3] The exhibition was held at the Laing Art Gallery, Newcastle, November 16, 1996–February 9, 1997, and the Barbican Art Gallery, London, June 19–August 17, 1997.

[4] For an excellent overview of the role that museums have played in creating and preserving the history of the videogame form, see Raiford Guins, *Game After: A Cultural Study of Video Game Afterlife* (Cambridge, Mass.: MIT Press, 2014), 31–70.

[5] See, for example, Michael Baxandall's tracing of the rise of the "Master's" hand—rather than raw materials—as the source of artistic and economic value in *Painting and Experience in Renaissance Italy* (Oxford: Oxford University Press, 1988), 23.

[6] Roland Barthes, "The Death of the Author," *Image-Music-Text*, ed. and trans. Stephen Heath (New York: Hill and Wang, 1977), 142–48; Michel Foucault, "What Is an Author?," *The Foucault Reader*, ed. and trans. Paul Rabinow (New York: Pantheon Books, 1984), 101–20.

[7] See, for example, Ronald R. Kline, *The Cybernetics Moment: Or Why We Call Our Age the Information Age* (Baltimore: Johns Hopkins University Press, 2015), 193–95. This question of the seemingly dwindling importance of individual agency in an increasingly systematized world was also of concern to the Frankfurt School thinkers. The homogenizing effects of postwar systems was famously deconstructed by Herbert Marcuse in his widely read volumes, such as *One-Dimensional Man: Studies in the Ideology of Advanced Industrial Society* (London: Routledge & Kegan Paul, 1964).

[8] For more on the interconnections between new media art and systems theory, see Francis Halsall, *Systems of Art: Art, History and Systems Theory* (Bern: Peter Lang, 2008), 122–23.

[9] For more information on the remarkable scales employed in *Inside a Star-filled Sky*, see http://insideastarfilledsky.net/bulletPoints.php.

[10] This ambivalence between maker and player has been an important leitmotif running through Rohrer's work, including *Chain World*, as well as a new game slated for release in 2016.

THINKING WITH VIDEOGAMES
BY PATRICK JAGODA
Assistant Professor of English, University of Chicago

Still from *Passage*

In early twenty-first century culture, many games—from older analog games with continuing player communities such as Go and bridge to contemporary videogames such as *Starcraft II*, 2010, and *Grand Theft Auto V*, 2013—are framed primarily as a means of entertainment. Throughout their longer history, however, games have regularly served as a medium that promotes critique and analysis. In 1939, historian Johan Huizinga wrote in his classic book *Homo Ludens* that games and sports are "played in profound seriousness," and that gameplay should be treated as a fundamental element of culture.[1] Examples of this awareness historically involve myriad martial applications of gaming: in the Middle Ages, chess was used as a way of teaching military strategy, and in the early nineteenth century, *Kriegsspiel* ("war game") was developed to train Prussian officers. In 1954, Rand Corporation analysts Alexander McFarlano Mood and R.D. Specht more systematically described gaming as "a technique of analysis" that continued to be applicable to realms such

as warfare.[2] Elaborating on other domains that games might impact, in 1970, the polymath Clark C. Abt coined the term "serious game," a category that far exceeds the realm of war strategy and tactics. Abt argued that "a game is a particular way of looking at something" and can be used to address issues in education, government, industry, and the sciences.[3] In the early twenty-first century, the design and study of games began to inform problem solving in interdisciplinary areas ranging from occupational training to public health.

At the same time, gaming became an artistic medium in which practitioners could explore significant philosophical and aesthetic ideas. In their artistic capacity, games had precursors earlier in the twentieth century (for example, in the work of artists such as Marcel Duchamp and André Breton, including the collaborative "exquisite corpse" technique), and by the late twentieth century had become institutionalized through exhibitions and publications (such as curator Beryl Graham's

groundbreaking 1996 art exhibition *Serious Games*).[4] However, it was only around 2007 that a noteworthy and widespread expansion of the category to include digital "art games" took place. This videogame scene grew through the emergence of auteur-style game designers such as Jonathan Blow, Mary Flanagan, and Paolo Pedercini. During the late 2000s, numer-ous factors encouraged both independently produced and artistically inclined games. These developments included the availability of online distribution platforms such as Steam that allowed players to install and automatically update digital games without discs or cartridges, the growth of indie and art game conferences such as IndieCade, and the rise of local maker movements supported by blogs and community events. The years between 2007 and 2009 also gave rise to a number of widely recognized art games, including Jason Rohrer's *Passage*, 2007; Rod Humble's *The Marriage*, 2007; Tale of Tales's *The Graveyard*, 2008; Jonathan Blow's *Braid*, 2008; thatgamecompany's *Flower*, 2009; and Paolo Pedercini's *Every Day the Same Dream*, 2009.[5]

Jason Rohrer has been a central figure in the art games movement. Crucial among his many accomplishments is the way he takes games—especially digital games—seriously as both a mode of thought and as an expressive medium. It is not that Rohrer's videogames merely adhere to some transhistorically stable definition of "thought" or "art." At a historical moment during which digital media have grown increasingly ubiquitous, his works are all the more important for the ways they use participatory and collective elements to reimagine these terms.

For over a decade, Rohrer has used game-specific features to explore concepts such as creativity, idealism, regret, police brutality, and self-defense. He began his game production in 2005 with *Transcend* (page 18). His work gained greater visibility with *Passage* (page 26), which was first exhibited at Kokoromi Collective's GAMMA 256 art game event in 2007 and in 2012 was added to the permanent collection of the Museum of Modern Art in New York. During this time, Rohrer also created several other short,

single-player games that perhaps more thoroughly resemble interactive philosophical meditations than popular videogames. These range from the 2008 *Gravitation* (page 30), a platformer that explores the extreme affective experiences of the artistic process, to the 2011 *Inside a Star-filled Sky* (page 68), a tactical shooter that interrogates the concept of infinity.

Since 2008, many of Rohrer's creations have been multiplayer games. These works explore a diverse range of ways that people relate to one another and play together. In *Between* (page 34), two players individually create colorful blocks and erect towers, engaging in asynchronous cooperation without ever seeing each other's avatars on their own screens. In *Sleep Is Death (Geisterfahrer)* (page 62), two participants work together, under time constraints, to co-create a compelling story. In *Chain World* (page 66), a game that won the 2011 Game Design Challenge at the annual Game Developers Conference, players took turns serially building up a virtual world and passing on a single USB flash drive (a unique object that more closely resembled a traditional artwork than a reproducible media piece) to new participants. Games such as *Diamond Trust of London* (page 72) call for complex strategies, while *Cordial Minuet* (page 84) requires players to make monetary wagers. In the videogame *The Castle Doctrine* (page 80), Rohrer experimented with even more intense competition by using the genre of the "massively multiplayer online game," creating a permanent world in which numerous co-present players protect their virtual property through elaborate security systems while simultaneously attempting to break into one another's homes. This game has inspired myriad emergent behaviors, such as one player's construction of binary counters that were used to create electronic systems so computationally complex to resolve that the act of triggering them crashed the game.

How, then, do Rohrer's games open up a unique way of thinking? To answer this question, it is worth considering, more broadly, the form of a game. As the field of "ludology" or "game studies" has emphasized since the late 1990s, as cultural objects games are notably different from

novels, paintings, and films. Whether a game is making an argument, telling a story, or inviting exploration of a world, it does so through features such as rules, mechanics, and objectives. In order to affect their execution and meaning, games, and videogames in particular, require players to act. As new media scholar Alexander Galloway contends: "Without action, games remain only in the pages of an abstract rule book. Without active participation of players and machines, videogames exist only as static computer code. Videogames come into being when the machine is powered up and the software is executed; they exist when enacted."[6] If videogames enable a particular kind of thought, then, we might posit that it is thought that takes place through action.

Rohrer uses the medium-specific elements of videogames to open up concepts and problems to the process of thinking. For example, his *Perfectionism* (page 40), a game "sketch" or short prototype, takes up its eponymous concept in a way that is unique to videogames. It is important to highlight that, given the technical and cultural differences among media, the idea of "perfectionism" might be represented very differently in a novel (through prose or narrative) or in a film (through montage or actors' performances) than it could be in a videogame (through active decision-making and participatory play). In Rohrer's single-player strategy game, the player undertakes an abstract task: she substitutes rows and columns in order to match up yellow squares with yellow frames, while moving between different levels. The limited number of turns requires a conservation of substitutions and movements between levels. These rules and objectives do not represent perfectionism, as novels, paintings, or films might—that is, primarily through text, images, and audio. Instead, the rules of *Perfectionism* actually evoke the desire for perfect balance and achievement that exists within each player, offering rules and objectives that produce an experience on which she can then reflect.

The centrality of mechanics and moves in games also yields another important factor: uncertainty. As game designer Greg Costikyan writes, "Games require uncertainty to hold our interest, and… the struggle to master uncertainty is central to the appeal of games."[7] Every move that a player makes affects the overall system and elicits particular, often unpredictable, responses from a computer or another player. *Perfectionism* relies on the attraction of what Costikyan calls "solver's uncertainty," a common feature of puzzle games. The unknowability of how the game's different levels might ideally be solved motivates the very perfectionist drive that is the game's object of inquiry.

By contrast, Rohrer's *Between* puts the player in a position in which she cannot know the nature of the rules or objectives, and even the world around her is uncertain. From the start, she must learn by experimenting within the game space. At the beginning, the player enters a dream world that, she is told, is the setting of a two-player game that plays out via a networked connection. However, once the game begins, the second player does not appear on the screen, and the role of this other is uncertain. The player might reasonably ask, "How am I connected to the other player and how do we affect each other?" Both players gradually learn that they must build a tower by composing blocks in particular color schemes. At moments, one player must wait for the other to catch up and, indirectly, take actions that will make progress possible. The game, then, puts the player in a reflective space of uncertainty. An understanding of the game's meaning is impossible except through a series of progress-oriented actions that are in part dependent on those of the other player.

This catalogue explores the myriad ways in which Jason Rohrer's art games encourage active and uncertain thoughts in their players. Many of Rohrer's topics—including death, dreaming, and artistic self-representation—find counterparts and inspirations in the history of art. Yet his videogames also explore contemporary computational media and technology. For instance, *i45hg* (page 50) experiments with the limits of single-player videogames, *Sleep Is Death (Geisterfahrer)* (page 62) explores the parameters and possibilities of interactive storytelling, and *Inside a Star-filled Sky* plays with the forms of recursion that computer

software is capable of enacting. As game studies scholar Brian Schrank observes, "Not only are videogames an advanced product of technoculture, they are also a major site on which culture naturalizes the ways in which we think and play with technology."[8] Especially with their increased recognition as a significant expressive form, videogames allow us to think about, and with, the digital technologies that are so central to our current historical moment. Rohrer continues to be one of the most important new media artists and game designers in part because he plays with the affordances of these technologies and, from this insider perspective, enables critical thought and reflection on them. More than this, however, his games often affect players emotionally, generating attentiveness to oft-ignored aspects of the everyday world. They also inspire new ways of approaching digital infrastructures and inhabiting our increasingly ordinary networked environments.

[1] Johan Huizinga, *Homo Ludens: A Study of the Play-Element in Culture* (Boston: Beacon Press, 1955), 6.

[2] Alexander McFarlane Mood and R. D. Specht, *Gaming as a Technique of Analysis* (Fort Belvoir, Va.: Defense Technical Information Center, 1954), 5.

[3] Clark C. Abt, *Serious Games* (New York: Viking Press, 1970), 5.

[4] *Serious Games* was held at the Laing Art Gallery, Newcastle, November 16, 1996–February 9, 1997, and the Barbican Art Gallery, London, June 19–August 17, 1997.

[5] Felan Parker, "An Art World for Artgames," *Loading …* 7, no. 11 (2013): 41.

[6] Alexander Galloway, *Gaming: Essays on Algorithmic Culture* (Minneapolis: University of Minnesota Press, 2006), 2.

[7] Greg Costikyan, *Uncertainty in Games* (Cambridge, Mass.: MIT Press, 2013), 2.

[8] Brian Schrank, *Avant-garde Videogames: Playing with Technoculture* (Cambridge, Mass.: MIT Press, 2014), 4.

GAMES

WINDOWS
MAC OS
UNIX

TRANSCEND

2005

Rohrer's first publicly released game, *Transcend*, adopts the genre of the "arena shooter," in which the player's avatar and enemies are confined to battle within a delimited space. Notably, the game comprises a singularly abstract interpretation of this typically commercial genre. All of the geometric characters (called "glyphs" in the game) are colored polygons that morph into and out of one another. In order to advance, you must destroy the level's major anti-glyph, or, in more typical videogame parlance, "boss." Achieving this goal requires you to assemble a kind of collage in the center of the level. As your collection grows, you gain the power to dispense with the minor anti-glyphs—who buzz around, seeking to disrupt any progress—and eventually the major anti-glyph, whose demise opens a portal onto the next level.

 The high degree of visual abstraction is matched by a compelling sound design. Overlaying the game's grid is the "music cursor," a red, yellow, and blue line that graphically represents the procedurally generated score, which is unique to each game. All elements of *Transcend* have an associated musical theme, and their arrangement along the music cursor determines how they will be rendered—either sequentially in time or arrayed in (simulated) space through stereo effects. But perhaps the most striking feature of *Transcend* is the "immortality" it grants players: enemies cannot actually kill your glyph. While many early critics felt that this aspect undermined the traditional challenge of such shooter games, from the beginning of his career Rohrer staked a claim on the aesthetics and strategy of videogames, whose more typical focus is on cultivating game-specific skills and reflexes. He describes this new kind of gaming experience as synthesizing traditional gameplay with the creation of an "abstract visual collage and… a unique piece of music."[1] —MM

[1] Jason Rohrer, "Transcend: A Videogame by Jason Rohrer," http://transcend.sourceforge.net/.

ARROW KEYS TO MOVE
SPACE BAR TO SHOOT
"D" KEY TO PICK UP OR DROP ELEMENTS

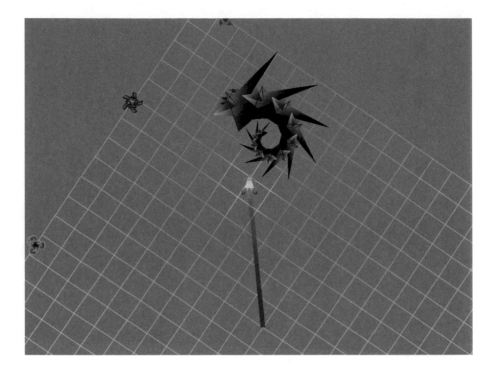

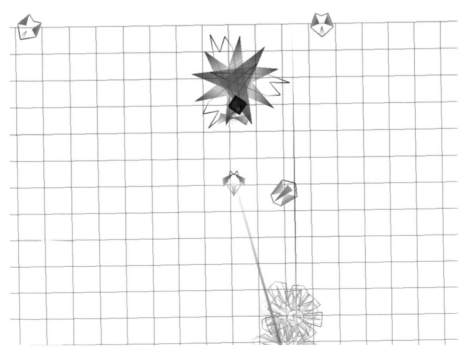

Destroying a major "anti-glyph" (level-boss)

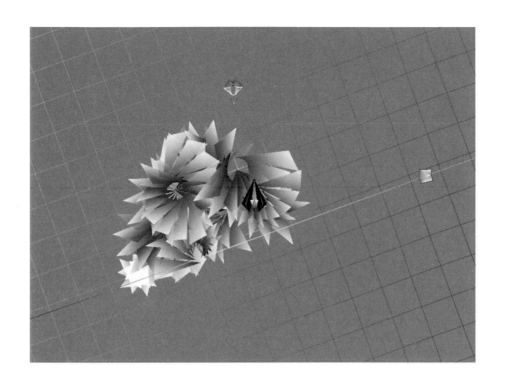

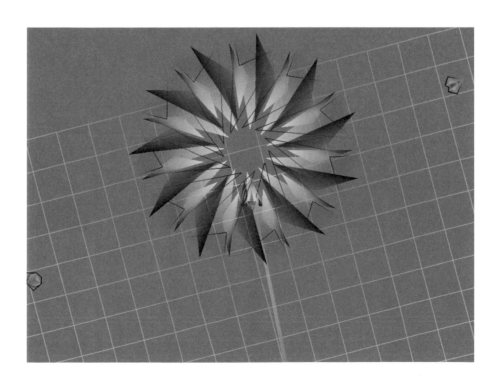

WINDOWS
MAC OS
UNIX

CULTIVATION

2007

Rohrer's second offering takes place in a gridded space inhabited by another set of colorful, procedurally generated characters. Unlike *Transcend* (page 18), whose central conflict is a straightforward antagonism, *Cultivation* concerns an interdependent competition for a finite set of resources. Your avatar is a "gardener," a kind of piscine creature dedicated to planting crops within a specific plot. As the game progresses, you mate and reproduce, gathering more plots in which to plant an increasingly complex array of hybridized crops. After a time, you encounter neighbors, whom you may treat generously by offering them your harvested crops. However, conflict inevitably arises: lands are fought over and eventually poisoned, rendering them useless for future cultivation.

Critics of the game tend to regard it as a straightforward illustration of the "tragedy of the commons," a social phenomenon in which shared resources are more likely to be degraded because they are not protected by private ownership. But *Cultivation* has a different meaning for Rohrer, who based it on his personal experiences as a community activist in Potsdam, New York. In the aftermath of a particularly internecine fight against a Walmart incursion, Rohrer began to focus his thinking outside the traditional gaming framework, seeking new ways to resolve conflict that go beyond the unqualified defeat of one opponent by the other. While "you want to fight for what you think is right," he wrote in the game's announcement, "the fighting itself can have enormous costs for both sides."[1] This attempt—to use games as a medium for thinking through intimate and difficult personal experiences—became a touchstone for much of Rohrer's subsequent production. —MM

[1] Jason Rohrer, "Cultivation Discussion," http://www.northcountrynotes.org/jason-rohrer/arthouseGames/seedBlogs.php?action=display_post&post_id=jcr13_1169054799_0.

Stills from *Cultivation*

WINDOWS
MAC OS
UNIX

ARROW KEYS TO MOVE THROUGH MAZE

PASSAGE

2007

Passage is a game in which the player controls a blond male avatar who explores a maze filled with different patterns and landscapes. The "passage" of its title gestures toward both space (an infinite world filled with tight passages) and time (each play-through lasts approximately five minutes). At the beginning of the game, you can attach to a female partner. You can also accumulate points by either collecting treasure chests (each adds 100 points to the score if it happens to be filled with treasure) or by exploring the world (a process that yields double the points if you engage in the activity with your partner). Regardless of the choices made, across five minutes, the avatar gradually shifts to the right side of the screen, invariably ages, and ultimately dies.

Passage contributes to the long artistic tradition of the *memento mori*, the reminder of mortality presented in images (such as the anamorphic skull in Hans Holbein the Younger's 1533 painting *The Ambassadors*) or text (for example, the fifteenth-century Christian *Ars moriendi* guides). In contrast to such historical works, Rohrer's interactive *memento mori* requires the player to be complicit in the protagonist's death. And unlike earlier Christian examples of the form, which often sought to shift attention from ephemeral earthly delights to the eternal salvation of the soul, *Passage* foregrounds a series of choices that are ultimately of little consequence. The player can experiment with the results of different decisions, especially on replay, once the game's short duration and ultimate outcome are known. As Rohrer puts it, the game asks the player, "Now that you've been reminded of your own mortality, what are you going to do with the rest of your life?"[1] Beyond this philosophical question, the game generates an emotional impact that can range from sustained melancholy and bittersweet reflectiveness to terror—given that none of the choices available to the player can avert the final outcome. At most, you have the freedom to select a path: pursuing a largely meaningless high score, finding love, or simply remaining still and listening to the soundtrack.

Though Rohrer has described the game as autobiographical, it also reflects on the generalizable experience of mortality. In this second respect, it is worth noting that the options for modes of living are here limited by parameters of white heteronormativity. It is notable that, in 2012, the Museum of Modern Art chose *Passage* to be one of the first fourteen videogames to enter its permanent collection. —PJ

1 Jason Rohrer, in Patrick Jagoda, "Between: An Interview with Jason Rohrer," May 2011, *Critical Inquiry* website, http://criticalinquiry.uchicago.edu/the_jason_rohrer_interview/.

Choosing a partner in *Passage*

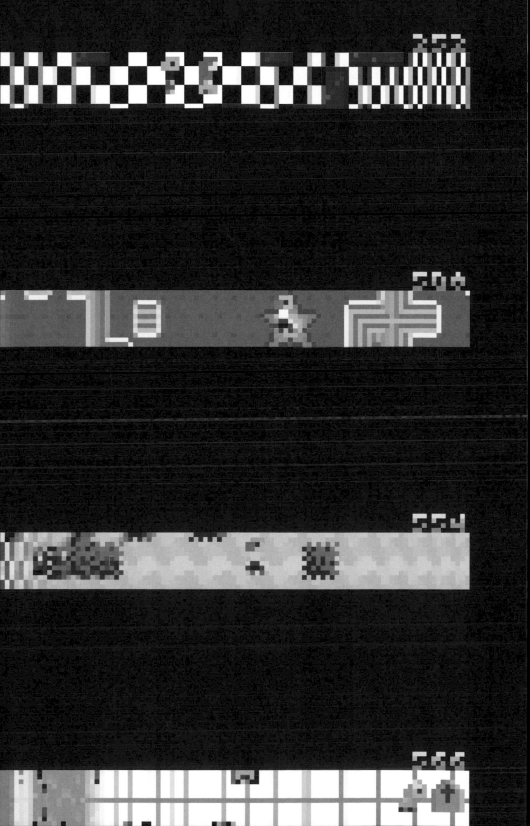

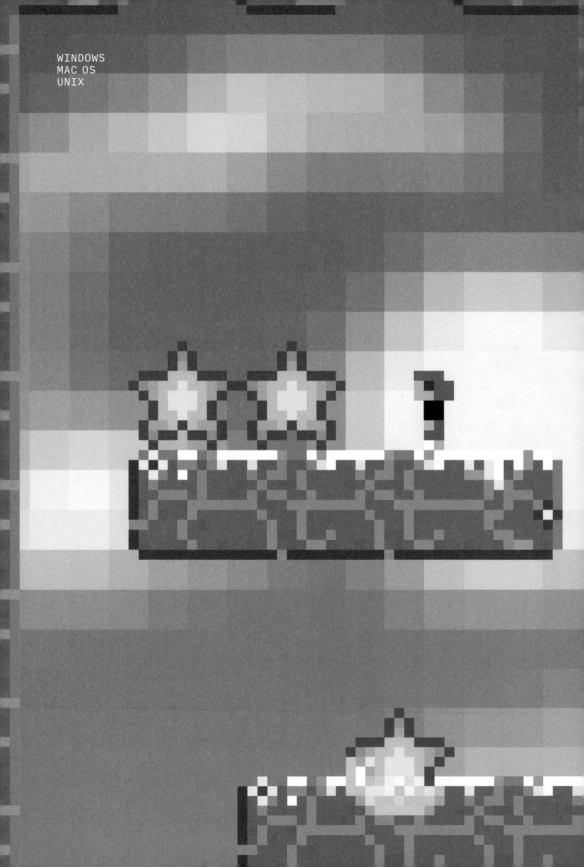

WINDOWS
MAC OS
UNIX

GRAVITATION

2008

With *Gravitation*, Rohrer grapples with his own emotional challenges in establishing a balance between work and family, and between flights of inspiration and bouts of melancholy. At the outset of the game, your avatar—a pixelated rendition of Rohrer himself—stands at the bottom level of a series of ascending platforms. To the left stands Rohrer's towheaded son, Mez, eager to play catch with a red ball. To the right is a furnace, its fire a metaphor for personal aspiration and creativity. As Rohrer, you can choose to play with Mez or to ascend into a maze where you will find stars. These stars, the source of points in the game, represent creative projects. Captured during your ascent, they fall to earth as blocks of ice, which you must push into the furnace in order to convert them into points. The progress of the game is conditioned by your avatar's fluctuations in mood—seemingly effortless movement on a full, bright screen alternates with labored motion on a grayed-out, constricted screen.

 Gravitation belongs to a long tradition in which artists picture and translate the highs and lows of the creative process. But what distinguishes Rohrer's game from Vasily Kandinsky's fevered early twentieth-century abstractions or Albrecht Dürer's sedate *Melencolia* of 1513–14 is the way Rohrer situates the vicissitudes of creative work not within the solitude of the studio but amid the interdependent and shifting needs of a family. While playing catch with Mez is the most expedient way to avoid a creative block, if you stay at the bottom you forgo the enticing possibilities of the rest of the game. Meanwhile, ignoring Mez and his ball leads to other negative consequences that we leave to players to discover. The title points to a necessary balance: between gravitational pull as both a hindrance to unbridled creativity and a force that keeps the creative artist at least partly grounded. —MM

ARROW KEYS TO MOVE
SPACE BAR TO JUMP

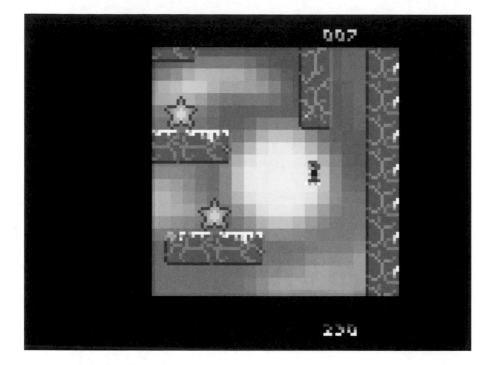

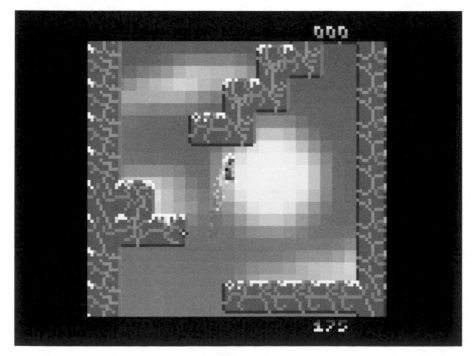

Stills from *Gravitation*

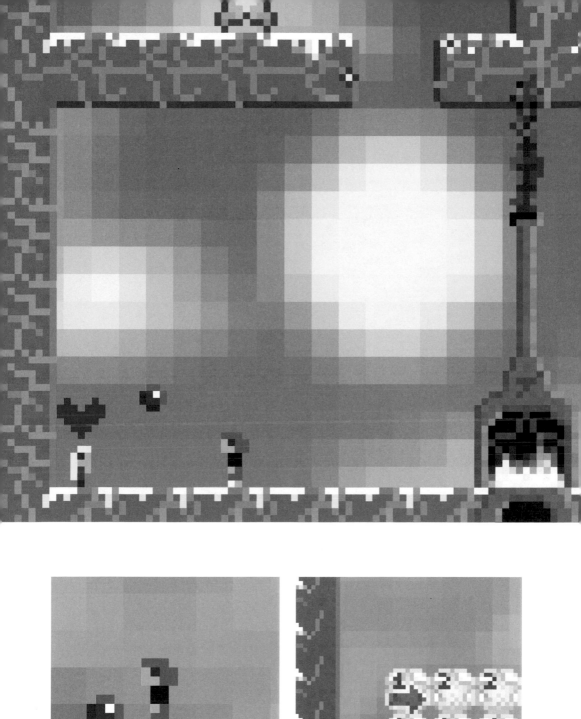

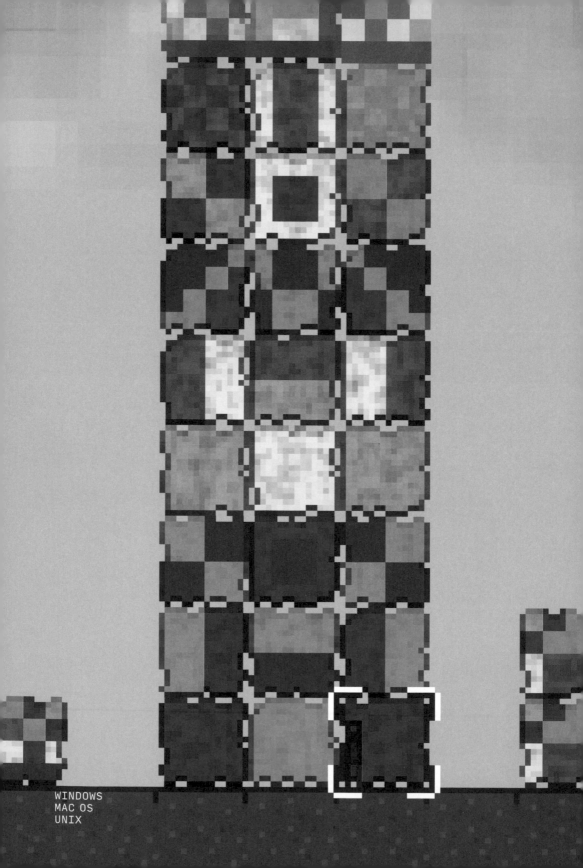

WINDOWS
MAC OS
UNIX

BETWEEN

2008

In this two-player game, the player finds herself in a world between sleep and waking. The avatar moves on a horizontal axis across a bounded level. At the center of the space, you discover a tower composed of colored tiles. By pressing the S and W keys (which stand for "Sleeping" and "Waking"), you move among three dream worlds that are identical except for the environmental distinctions of grass, soil, or tundra, all with their own tower. In each world, you must generate colored blocks, using a two-by-two frame and an inventory of red, green, and blue blocks. Once the blocks match those on the tower template, they can be placed in a corresponding slot. At each correct placement, a song plays, incrementally assuming new sonic layers. The goal of the game is to complete the towers.

In an introduction to the game, Hohrer requests that the two players be in different rooms or avoid looking at each other's screens as they play.[1] Without the information that access to both screens might yield, the nature of the relationship between the two players is not certain at the beginning of the game. The players' actions affect each other's games, but their avatars never appear on the same screen. As such, *Between* is a multiplayer game that engages in what game scholar Ian Bogost calls "disjunctive multiplay."[2] In particular, the multicolored slots on the towers include not only the red, green, and blue blocks that are available in your inventory, but also magenta, yellow, and cyan blocks that are not accessible at the game's start. These three other block types appear only when the other player makes progress. *Between* thereby meditates on forms of interdependence and intimacy, even between strangers who are linked through a computer network.[3] —PJ

[1] Jason Rohrer, "Between: A New Video Game," *Esquire*, November 18, 2007, http://www.esquire.com/news-politics/a5329/rohrer-game/.

[2] Ian Bogost, "Persuasive Games: Disjunctive Play," *Gamasutra*, November 8, 2008, http://www.gamasutra.com/view/feature/132247/persuasive_games_disjunctive_play.php.

[3] For an extended analysis of *Between*, see Patrick Jagoda, *Network Aesthetics* (Chicago: University of Chicago Press, 2016).

UP AND DOWN ARROW KEYS TO NAVIGATE MENU
SPACE BAR TO SELECT MENU ITEMS
REMAINING INSTRUCTIONS GIVEN DURING GAMEPLAY

BEYOND OUR GRASP
BY JASON ROHRER

This article is reprinted from *PC Gamer*, no. 205 (October 2010): 26.

Like most game designers, I'm a lifelong game player. But looking back from year 32, I've noticed a troublesome pattern that seems to be shared by other people my age. As I passed through my twenties, fewer and fewer mainstream games appealed to me. The past six years have brought a severe dry spell, with only a handful of games feeling like they were worth my time.

Much noise has been made over the idea of games "growing up." Can't we augment our library of candy-colored dreamworlds and male tween gun-fests with a few games about the things that matter to grownups? Moral dilemmas, relationships and other mature stuff like that. Okay, that sounds doable—and given that the average age of a gamer is 35, the money is ready and willing.

SOMETHING AMISS

I recently got a PlayStation 3, nearly four years into its life cycle, with 600 games in its library. What should I play? Games with interesting dramatic choices like *Fallout 3* (nuke or don't nuke an entire town?) and *Heavy Rain* (be strict or lenient with my kid?) seem like they were made just for my supposedly mature tastes. Nuclear war. Parenthood. Games have finally grown up. But something was still missing.

I could critique these games from a design perspective, discussing player choices, drama engines or simulation versus authorship. Maybe what's missing is better mechanical design, and we can imagine some mythical future game that gets it all right. But I don't think that's it.

Along with being a lifelong game player, I've also been a lifelong film watcher, but I haven't noticed a similar dearth of worthwhile films as I've gotten older. I can barely keep up with all the recent stand-outs, like *No Country for Old Men*, *Antichrist*, or *Synecdoche, New York*, nor can I exhaust the archives of weighty films like *Naked*, *Safe*, or *3 Women*.

SPEECHLESS

So what sets these films apart? Try to sum up what each of them is about. Not just on the surface, like what is written on the DVD jacket ("A drug deal gone bad and a suitcase full of money!"), but what they are about at their core. You will struggle. You will stammer. You will find yourself reaching for words that you cannot quite grasp.

And that is what we are missing. Reaching. What are games *about*? Why can we sum them up in a few sentences without missing anything? Why do we come away from them with nothing to think about and little gained beyond the transient enjoyment of playing?

Our stand-out games happen to be the ones that reach—maybe just a tiny bit, but that's enough to set them apart. *BioShock*. *Portal*. *Shadow of the Colossus*. What is *BioShock* about? "The downfall of Randian Objectivism." Yes, you can sum it up, but at least it's a mouthful. At least it sends most non-philosophy majors scrambling for Wikipedia.

These tiny reaches aren't good enough, though. I'm calling for gigantic reaches. Reaches big enough to carry us forward into the territory of foundation-shaking, transformational experiences, into the home turf of films like *Synecdoche, New York* (whose title *alone* will send you scrambling for Wikipedia).

Reaching sounds financially risky, and reaching with a novel mechanical design probably is. My proposition is far more modest: designers must reach with what their games are about. Go ahead and make a by-the-book FPS or cash-cow sequel—that's what pays the bills. But when you're sculpting your game's soul, don't stop pushing until your fingertips are barely brushing a tiny corner of something frighteningly enormous.

Forget the overly simple earmarks of "maturity." March us, as game players, right to the edge of the abyss.

Then shove us in.

GAME DESIGN SKETCHBOOK

In 2008, the magazine *The Escapist* commissioned Rohrer to create a series of seven playable videogame prototypes or game sketches, which were released online once a month. This sketchbook included: *Perfectionism* (March 14), *Idealism* (April 11), *Police Brutality* (May 9), *Immortality* (June 13), *Regret* (July 11), *i45hg* (August 8), and *Crude Oil* (September 5). Each prototype explores a different philosophical, political, or design concept through a distinct game genre. Instead of operating as fully polished games, these experimental sketches foreground videogames as a unique form of thought that depends not on language, but on mechanics, rules, systems, objectives, participation, and multiplayer interactions. —PJ

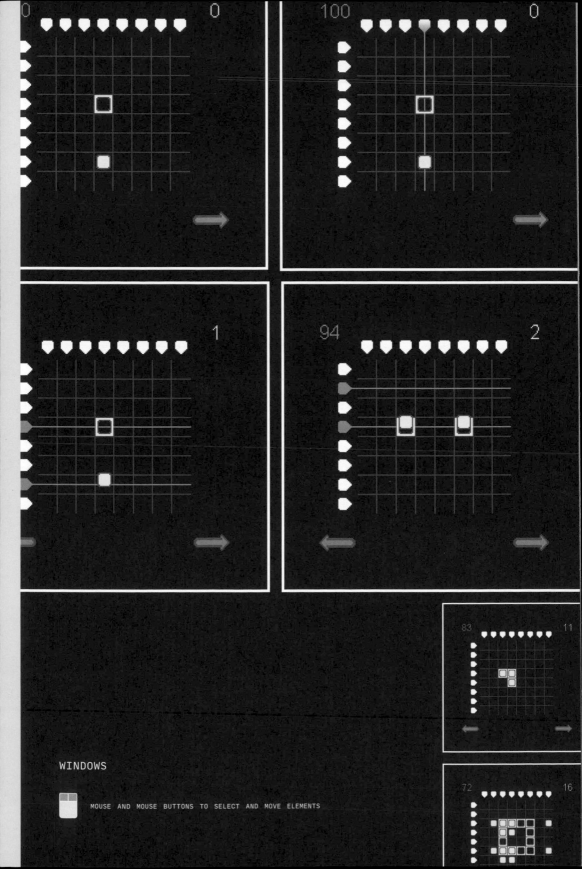

WINDOWS

MOUSE AND MOUSE BUTTONS TO SELECT AND MOVE ELEMENTS

PERFECTIONISM

2008

Rohrer's first game designed with GameMaker software, *Perfectionism* explores the experience of and aspiration to perfectionism, including its pitfalls. This prototype is a single-player puzzle game with strategy elements. Each screen presents a grid of eight rows and eight columns. The player can substitute any row or column for any other by clicking on one of two white tabs. The objective, on each screen, is to align the solid yellow squares with the yellow frames. You can also move among the existing screens, which make up twenty-one levels. The challenge of *Perfectionism* lies in the fact that the player has only one hundred moves, and each row or column swipe, as well as each move backward or forward to another level, counts as one. Thus, you must balance several simultaneous and parallel tasks, represented as levels.

In some ways, *Perfectionism* builds on and critiques the type of entertainment that is common in popular "casual games," from *Bejeweled*, 2001 to *Candy Crush*, 2011. Beyond offering the basic engagement with the primary challenge, Rohrer's game conveys meaning using only its game mechanics and rules, and not language. The game gives the player an experience of pursuing a flawless performance. It can also be interpreted as a meditation not only on perfectionism in general, but on computer programming specifically. As Rohrer writes: "Programming isn't like carving something out of marble, where if your sculpture's nose is too small, you must either live with it or start over with a fresh block of marble. Our code bases can be massaged indefinitely."[1] Programming can inspire obsessiveness and detail-oriented precision in the programmer, driving the pursuit of more elegant code or the elimination of bugs, often far beyond the point of productive returns. Here, Rohrer brings the experience of perfectionism alive through the medium of games. It operates as an "allegorithm," to borrow media scholar Alexander Galloway's neologism that combines the words "allegory" and "algorithm." In other words, Rohrer's game produces an allegory of perfectionism through its algorithms and game mechanics.[2] The gameplay of *Perfectionism* looks forward to Rohrer's more fully realized game *Cordial Minuet* (page 84). —PJ

1 Jason Rohrer, "Game Design Sketchbook: Perfectionism," March 14, 2008, http://www. escapistmagazine.com/articles/view/video-games/ columns/gamedesignsketchbook/3018-Game-Design-Sketchbook-Perfectionism.

2 Alexander Galloway, *Gaming: Essays on Algorithmic Culture* (Minneapolis: University of Minnesota Press, 2006), 91.

aim with mouse, [space] to shoot

IDEALISM

Idealism explores the tension that arises when ideals and goals are incompatible. This philosophical reflection takes the form of a single-player, turn-based arena shooter game with an overhead perspective, which resembles earlier games such as Namco's *Bosconian*, 1981. Configured for a keyboard and mouse, *Idealism* requires clicks for movement, but by enabling aiming and shooting when the avatar is in motion, reduces the number of keys that make up the control scheme. Throughout the game, the player maneuvers an avatar (white icon) through each level with the objective of reaching a passage (blue asterisk) to the next. With the turn-based format, game time passes only when you move the avatar through each level. In order to traverse the levels, you must avoid enemies (red icons) by outmaneuvering them and shooting down the red minions they send out in pursuit. As the game progresses, you encounter supporters (green diamonds) that shoot at the red minions. However, if you choose to violate your ideals (green blocks that disappear once touched) in order to generate an easier path through the level, your supporters first become neutral and withdraw their aid (yellow diamonds), and then actively turn against and shoot you (red diamonds).

In contradistinction to the velocity of most button-mashing arena shooter games, the turn-based arrangement of *Idealism* promotes slow movement, strategic thought, and personal reflection. Through its ruleset, the game foregrounds the tradeoffs between preserving your ideals (by maintaining the aid of the supporters), and privileging the easiest choice (by following the shortest path to your goal yet antagonizing the supporters). At another level, this central dilemma represents a more abstract tradeoff between the often opposed values of individual achievement and community participation. Instead of the binary decision trees that are featured in many videogames, *Idealism* allows the player to experiment with different values and strategies at each moment of gameplay. —PJ

ARROW KEYS TO MOVE
MOUSE TO AIM
SPACE BAR TO SHOOT

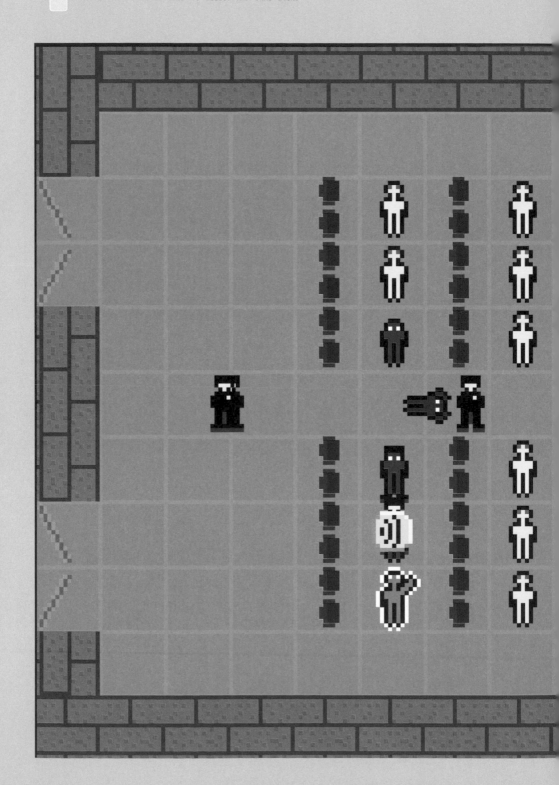

POLICE BRUTALITY

2008

This point-and-click strategy game explores possible approaches to limiting police brutality and the escalation of violence that accompanies it. The game takes place in a room where a public event is unfolding. Police infiltrate the event and begin to drag activist figures out of the space. The room is filled with three kinds of spectators, who are terrified (red), may consider helping (yellow), and are ready to help (green). The player can click on and activate only spectators who are ready to help. Clicking a yellow icon above these figures makes them shout. Dragging the shout radius and clicking on terrified spectators converts them into potential or willing helpers. The shout, however, also attracts attention from police, so you must quickly move among different figures to distract or trap police. You can also move figures that are ready to help across the grid in order to block police. The objective of the game is to keep police from dragging people out of the room. If the police forces are divided or blocked, you win.

This game sketch simulates a complicated affective and ethical situation. Though the game's historical and spatial scene remains unspecified, it calls to mind countless episodes of police brutality, including the violence of the 1963 Birmingham campaign, the 1968 Democratic National Convention riots in Chicago, and the 1999 "Battle in Seattle" protests against the World Trade Organization. The game remains relevant, perhaps more so than ever, due to its resonance with events such as the 2014 police shooting of Michael Brown in Ferguson, Missouri, and the anti-racist protest that this violent event (and others like it) inspired. *Police Brutality* also encourages the player to push against the "bystander effect," a social psychological principle in which people who witness a violent event do not intervene to help a person who is under threat, especially when large groups are present. In this game, the player controls a collective group that includes individuals willing to overcome their fear and take risks to help others being subjected to physical violence. —PJ

IMMORTALITY

2008

This game prototype explores the question of whether immortality, if achievable, would be a desirable state. At the beginning of the game, a timer starts counting down from five minutes. Your avatar can move left and right across a two-dimensional plane, encountering gray blocks that obstruct your path, as well as blocks that offer handholds for climbing over them. Both block types can be picked up and moved. In the center of the playing field, which stretches beyond the immediate screen, you can stack blocks in order to increase the score. You discover that you can also build a small tower to collect a skull block (which causes the countdown timer to speed up and results in immediate death), acquire an infinity block (which removes the timer and offers infinite time to play the game), or avoid both blocks (which allows play for exactly five minutes).

Immortality operates more like an interactive thought experiment than a traditional game. If you acquire the infinity block, the game and score acquisition can continue indefinitely. However, with this choice, the game intentionally becomes boring, or at least repetitive, very quickly. Rohrer, thus, uses a game without an objective (other than the accumulative imperative to stack up more blocks) to allegorize and simulate a life without end. Alongside *Passage* (page 26), this game represents another of Rohrer's reflections on death. As he writes: "If you could become immortal, would you? *Immortality* is a game about that question, and it's also about the converse of that question: Does death have some fundamental value that we usually ignore?"[1] The player's choices and consequent experiences in the game make these questions concrete and memorable. —PJ

[1] Jason Rohrer, "Game Design Sketchbook: Immortality," June 13, 2008, http://www.escapistmagazine.com/articles/view/video-games/columns/gamedesignsketchbook/4966-Game-Design-Sketchbook-Immortality.

ARROW KEYS TO MOVE
SPACE BAR TO PICK UP AND DROP BLOCKS

ARROW KEYS TO MOVE THROUGH MAZE
SPACE BAR TO FEED ANIMALS

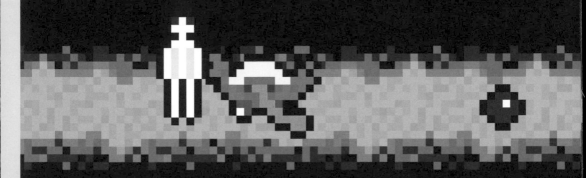

WINDOWS

REGRET

2008

Regret, a prototype that emerged from a prompt suggested by a visiting journalist, is a maze game that explores feelings of remorse about fatal errors. The player moves through winding pathways with the objective of collecting as many blue icons as possible. Along the way, five species of animals appear: frogs, cardinals, owls, rabbits, and squirrels. Through trial and error, you must match a food item—carrot, cheese, grapes and wine, bread, or apple—that is randomly linked to a particular species that is able to consume it. If you feed the wrong food to the animal, it is poisoned and dies. You are subsequently haunted by a ghost of the animal, which blocks your path, slowing down progress and decreasing the number of blue balls you can collect. The game ends when you reach a star at the end of the maze.

Rather than teaching the player techniques for overcoming regret, the game allows the player to simply dwell within the feeling. In this way, Rohrer's work differs from many so-called "persuasive games" that make an argument or convey an opinion.[1] *Regret* invites players to reflect on the affective impact of a game-based experience and to situate it within their personal history. Once you begin accidentally to poison animals, the pace of the game slows, as you are blocked or paralyzed by regret every few steps through the maze. Videogames, in their development as an expressive form, have increasingly evoked a range of emotions that are elicited by narrative, characters, role-playing, and forms of involvement in interactive worlds. *Regret* may generate feelings, but it does something more by being *about* a feeling. In this respect, it is related to other experimental and art games such as Doris Rusch's *Elude*, 2010 and Jordan Magnuson's *Loneliness*, 2011. —PJ

[1] Ian Bogost, *Persuasive Games: The Expressive Power of Videogames* (Cambridge, Mass.: MIT Press, 2007).

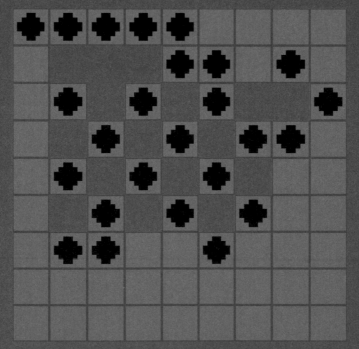

MOUSE AND MOUSE BUTTONS TO MOVE ELEMENTS

GAME DESIGN SKETCHBOOK

i45hg

2008

This game explores the limits of a single-player game—its maximum possible complexity and depth. On each turn, the player positions nine available white stones on blue squares within a nine-by-nine grid. Once a move has been decided, you click the green arrow to commit to your move and continue to the next round. As Rohrer explains, during each round, there are three key rules:

1. A white stone that is adjacent to one or more black stones scores a point.
2. A white stone that has less than three white neighbors becomes black.
3. A square that has three or four black neighbors is removed from the game (replaced with a blank, unusable square).[1]

After each round, the software counts up the cumulative points and adjusts the stones according to the ways the rules impact them. The objective of the game is to score as many points as possible.

Rohrer challenges the idea that, in order to achieve meaningful expressive dimensions, videogames need to draw primarily from media such as novels, which individuals usually experience alone. In his *oeuvre*, which has built increasingly toward multi-player games, he grapples with the limits of single-player games. Solo games are common among entertainment games of the 1970s through the 1990s, and recur in art games and story-based games of the early twenty-first century. Continuing to experiment with single-player games, Rohrer's *Inside a Star-filled Sky* (page 68) uses a nesting doll structure and recursion to create a solo game experience that is functionally infinite. Rohrer's question in *i45hg*, however, is more fundamental: Can a single-player game, sans artificial intelligence, random elements, or physical challenges, ever equal the infinite replayability and complexity of a two-player game such as Go? Based on this game experiment, Rohrer concludes that single-player games lack the type of emergence that a human opponent or collaborator can bring to a gameplay experience. No matter the specific design decisions or modifications, we might observe, chess will always have more potential than solitaire. —PJ

[1] Jason Rohrer, "Game Design Sketchbook: Testing the Limits of Single-Player," August 8, 2008, http://www.escapistmagazine.com/articles/view/video-games/columns/gamedesignsketchbook/5123-Game-Design-Sketchbook-Testing-the-Limits-of-Single-Player.

$ 5

Your mov

7		
27		
27		

change in Demand = (Supply - Demand) / 2

Demand: 2

CRUDE OIL

2008

17

Price

Crude Oil is Rohrer's first two-player game that is played across a networked connection. Each player takes the perspective of an oil company that must balance between extracting oil and selling it immediately, on the one hand, and withholding oil and selling it at a higher price later. You and your opponent make moves at the same time. You never see an opponent's move before submitting your own. During each turn, you bid on the lease of plots from which to pump oil, an action that costs $1 per unit. The oil that you pump enters your supply pool and the market. If you run out of money during the game, you can no longer act, and lose the game. During play, oil supply impacts demand after each turn. The interval between supply and demand determines the price of oil (the price being $2 per unit when supply equals demand). The player with the greatest profits at the end of the game wins. *Crude Oil* cannot be run on any operating system that follows Windows XP, marking the ongoing archival challenge of preserving computer games.[1]

Rohrer was inspired to create *Crude Oil* during the 2008 U.S. presidential election, when drilling for oil in the Arctic National Wildlife Refuge (ANWR) in northern Alaska was a major issue. Candidates Barack Obama and John McCain were united in opposing George W. Bush's efforts to reverse a ban on offshore drilling. Rohrer became curious about what the oil industry would do if granted the rights to drill in ANWR. As he puts it: "If you pump all your oil out today and sell it at today's price, you won't have any to sell at tomorrow's price. What if tomorrow's price is much better than today's price?" *Crude Oil*'s competitive simulation explores contemporary issues related to fossil fuels and the energy crisis. This game shares both gameplay and thematic similarities with Rohrer's later game *Diamond Trust of London* (page 72). —PJ

[1] For more on issues of videogame preservation, see Raiford Guins, *Game After: A Cultural Study of Video Game Afterlife* (Cambridge, Mass.: MIT Press, 2014).

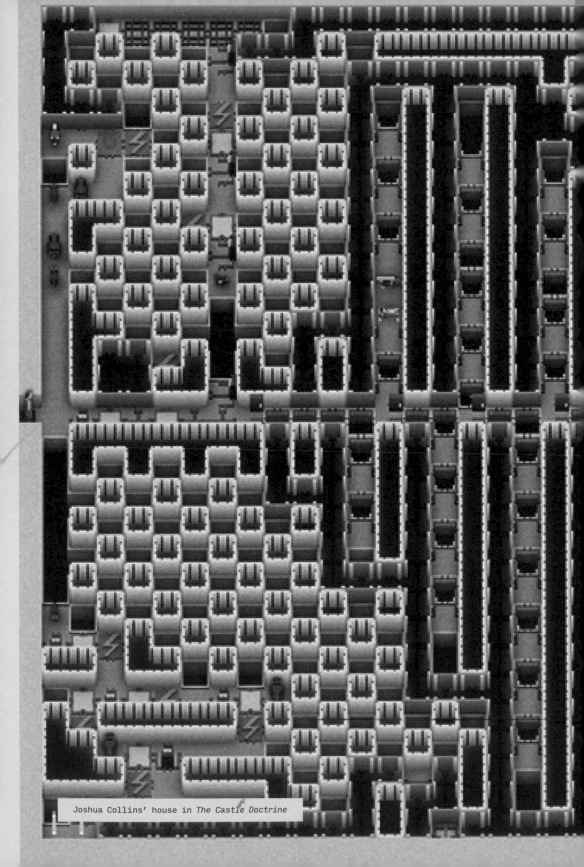

Joshua Collins' house in *The Castle Doctrine*

A PLAYER'S PERSPECTIVE: JOSHUA COLLINS INTERVIEWED BY PATRICK JAGODA

The field of game studies has drawn heavily from formalist approaches that analyze games based on their textual, graphical, and procedural dimensions. Increasingly, however, scholars have supplemented investigations of game structures by analyzing some of the ways in which games are played, exploring metagaming practices that exceed designer intentions, and applying qualitative methods taken from the social sciences (such as player interviews and ethnographies).[1] With these approaches in mind, we reached out to one of the most successful players of Jason Rohrer's games. Joshua Collins (who goes by several handles, including "joshcol" and "joshwithguitar") has pushed the in-game electronics of *The Castle Doctrine*, requiring Rohrer to create patches and updates to respond to his discoveries, and has also acquired top scores in *Cordial Minuet* (page 84) and *Primrose* (page 58).

Patrick Jagoda: What have you learned about Jason Rohrer's games from playing them at such a high level?

Joshua Collins: *Passage* and *Gravitation* were the first games I'd really seen that aimed primarily to express something rather than present a challenging distraction. These games used game mechanics in a way that integrated perfectly with what the game was trying to express.

So what have I learned about his games? One thing is that a deceptively simple premise and system can lead to countless possibilities and exploration. In *Primrose*, *The Castle Doctrine*, and *Cordial Minuet*, Jason had no idea when he created them the kind of play that would emerge. Despite this complexity, each game is very accessible and can be played at a much more basic level and still be enjoyed.

PJ: How did you become a top player of *Primrose*?

JC: I joined *Primrose* after the final patched version was released and after a lot of players had given up on it. In the older versions, there was a method to trivially gain huge amounts of points in the endgame through a tedious and repetitive mechanism. When Jason patched it, a lot of players left. So when I joined there was hardly anyone playing, but the game was now really interesting, requiring considerable thought to create high scores.

One feature of the game is that you can view all the games on the top score list from start to finish. At first I avoided this to try to get a feel for the game myself and see if I could come up with my own ideas. Eventually, I looked at the top scores, though, and saw that they all applied the strategy of creating a long chain reaction followed by a large "pot" of squares to capture. I noticed, though, that they weren't doing this very efficiently and went about creating my own long chain designs that fairly quickly got me to the top of the list (the top score at the time was, I think, around fourteen million dollars). After this, I was on my own, as none of the few remaining players seemed interested in beating the top scores and I set myself the challenge of making higher and higher scores and reaching a hundred million.

A year or so later, I was interested in having a look again and found an even better chain layout that boosted my score to a hundred and eighty million. This seemed pretty optimal to me, but I started to wonder whether you could keep making significant points in the endgame, something that hadn't come up. Eventually, after a bunch of tests, I found a method of clearing the map and then building a long chain. At this point, the game became really interesting to me, as it offered new challenges each time I'd try to clear the map in different layouts that would emerge. Using this method, I was able to double my top score.

PJ: How were you able to master *Cordial Minuet,* given that you're at the top of the leaderboard as of this conversation? What was the largest bet that you made on that game?

JC: It took me a while to get to the very top of *Cordial Minuet.* **For my first few months, I'd often hover around the second or third place on the Elo leaderboard, but rarely have the top place. One thing that gave me an edge fairly early on was that I was one of the few players to start using computer assistance (something that Jason had said he was fine with people doing), which I found quite surprising, as there is a running joke that pretty much all** *Cordial Minuet* **players are programmers. At first, the computer aid wasn't helping that much, though if I blindly followed its suggestions, my play would become too predictable, and so against top players I'd still have to put in a lot of effort.**

I refined my skills over time, though, and kept tinkering with my custom-built client until I eventually came upon the strategies that I use today. I started doing well during the middle of the launch tournament, and by the end, my new way of thinking had won me the last five days of the twelve-day competition. After this, I maintained my lead and the only player that stood in my way was a mysterious player called "Jeopardy Alcohol" (JA) that I had had a long rivalry with, both winning and losing a lot of money to. JA had made a much larger profit than me at the time. At first, my new strategies seemed to do well against JA, but then I started losing money in a few higher-stakes games and went back to the drawing board. After a few strategy refinements, I got to the point where I was consistently beating JA and overtook them on the profit boards.

The largest two bets I made were both for a hundred dollars and I lost both, so I haven't been game to take such risks again. I've played a bunch of games in the forty-to-sixty-dollar range. I'm not sure what the largest game was for. Nate won over six thousand dollars from Cullman, so I imagine they must have played some pretty high-stakes games. This was all before I joined, though. I'm fairly certain that games of over five hundred dollars have occurred.

PJ: According to Jason, you pushed *The Castle Doctrine* to new levels, leading him to create patches of the design. Could you tell me more about those discoveries?

JC: My brother Joel and I started getting interested in electronics when we discovered that creating circuits looped back on themselves led to interesting outcomes. This eventually led us to finding methods of creating binary counters and finding ways to send complex signals through wiring systems, among other things. The discovery and further refinement of binary counters caused us to figure out a way to design an electronic system so computation- ally complex to resolve that activating it would crash the game, effectively killing anyone in your house at the time. Resisting temptation to try it out in the game, I sent it off to Rohrer who had to put a limit on computation within houses.

Probably our biggest discovery was how to build clocks in the game that would increment each time you made a step or used a tool. Joel came up with the initial discovery of their possibility, and I was able to come up with a practical design. Once we revealed our discov- ery to the community, it had a large effect on the game, and houses making use of clocks in interesting ways became common. Jason initially wanted to remove the possibility, but we were able to convince him that because of the large amount of space required to create a clock they were not game-breaking. Through exploring the electronics, I learned fairly quickly that the possi- bilities in the game were countless. While I was active, I kept working on making smaller and smaller clocks and counters, and just when I thought I'd reached the limits of miniaturization, I'd discover a way of making it even smaller. Just working on solving challenges we set ourselves with the electronics was fun on its own—Joel hardly even played the game.

1 For more on the centrality of play to game studies, see Miguel Sicart, *Play Matters* (Cambridge, Mass.: MIT Press, 2014). For more on metagaming, see Stephanie Boluk and Patrick LeMieux, *Metagaming* (Minneapolis: University of Minnesota Press, forthcoming). For more on the use of qualitative methods in game studies, see Adrienne Shaw, *Gaming at the Edge: Sexuality and Gender at the Margins of Gamer Culture* (Minneapolis: University of Minnesota Press, 2014).

MORE GAMES

179,
913,816

PRIMROSE

2009

An elegant and deceptively simple puzzle game, *Primrose* begins with players being given a pair of colored tiles to place in a seven-by-seven grid. The goal in placing the tiles is to surround each color with like colors, which causes the inside tiles to disappear and the outside ones to assume the color in question. As the board fills up, chain reactions—with exponentially increasing score bonuses—become possible. However, danger quickly mounts as the open spaces disappear: the game ends when the board is completely full of tiles.

With *Primrose*, Rohrer explores the terrain of what he terms "deep play."[1] In his analysis, both commercial and art-house games too frequently shortchange the essential mechanics of gameplay: while blockbusters focus on graphics and effects, so-called "indie games" privilege storytelling and emotional expression. As an alternative, *Primrose*, like chess or Go, places emphasis on its own mechanics rather than on an external visual or narrative rationale. The process it calls for, which might be likened to composing a piece of music or painting an abstract canvas, has made the early *Primrose* the only one of Rohrer's games that he himself continues to play regularly. —MM

[1] Michael Thomson, "*Primrose:* An Interview with Jason Rohrer" IGN (February 20, 2009) http://www.ign.com/articles/2009/02/21/primrose-an-interview-with-jason-rohrer.

ALL TIME			
364,720,346		210,889,744	
258,888,183		198,903,107	
248,353,152		180,771,318	
229,196,947		180,357,785	

TODAY			
85,053		44,126	
72,627		36,075	
51,817		30,844	
50,856		25,165	

320

46

1,208

24

40,
225,788

179,
894,435

202

282,
990,320

364,
720,346

SLEEP IS DEATH (GEISTERFAHRER)

2010

Instead of offering a wholly pre-authored play mode, *Sleep Is Death (Geisterfahrer)* relies on its two players to tell a story together. All of the scenes unfold in an oblique perspective, at a right angle, in which, for example, the tops and fronts of blocks are exactly the same size. This style approximates a common perspective taken in Japanese role-playing games such as *Secret of Mana*, 1993, and *Chrono Trigger*, 1995. The first player serves as the game master, who creates a narrative setting by laying out scenery and placing objects within it. This player can use preexisting graphical assets or create new ones before the game begins. The second player controls a particular character and explores the world that the first player has conceived. During a game session, both players can move characters and assign them speech bubbles. The first player can change the scene at any time. Though it is a two-player game, *Sleep Is Death* has inspired some players to post their story performances on YouTube for a broader audience of spectators to experience.

Even though *Sleep Is Death* serves primarily as a platform for storytelling, its game-like quality comes from the time-based constraints it places on players. Each participant has only thirty seconds to make a move before the other responds. The unfolding and completion of the story depends on these quick exchanges. The time limit distantly resembles language-based constraints that accompany the production of literature, from the formal conventions of the sonnet to the self-imposed constraints set by members of the French literary collective Oulipo. Arguably, however, *Sleep Is Death* draws its interactive constraint more directly from games than from literary culture. Turn-based analog card and board games often set strict rules for engagement, and videogames frequently set time limits for completing particular levels. An even more direct precursor might be tabletop role-playing games, such as *Dungeons & Dragons*, 1974, which interweave games and stories. —PJ

WINDOWS
MAC OS
UNIX

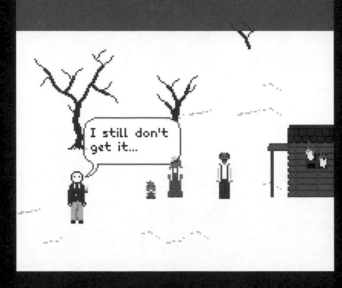

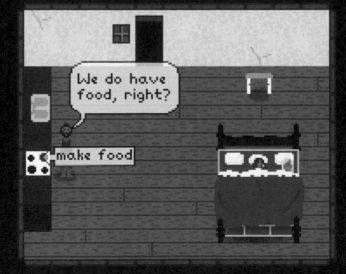

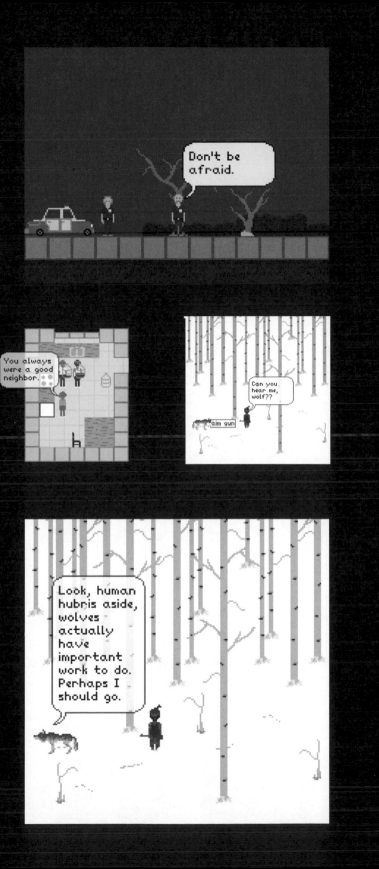

THE 9 COMMANDMENTS OF CHAIN WORLD

1. RUN CHAIN WORLD VIA ONE OF THE INCLUDED "RUN_CHAINWORLD" LAUNCHERS.

2. START A SINGLE-PLAYER GAME AND PICK "CHAIN WORLD."

3. PLAY UNTIL YOU DIE EXACTLY ONCE.

3A. ERECTING SIGNS WITH TEXT IS FORBIDDEN— YOUR WORKS MUST SPEAK FOR THEMSELVES.

3B. SUICIDE IS PERMISSIBLE.

4. IMMEDIATELY AFTER DYING AND RESPAWNING, QUIT TO THE MENU.

5. ALLOW THE WORLD TO SAVE.

6. EXIT THE GAME AND WAIT FOR YOUR LAUNCHER TO AUTOMATICALLY COPY CHAIN WORLD BACK TO THE USB STICK.

7. PASS THE USB STICK TO SOMEONE ELSE WHO EXPRESSES INTEREST.

8. NEVER DISCUSS WHAT YOU SAW OR DID IN CHAIN WORLD WITH ANYONE.

9. NEVER PLAY AGAIN.

CHAIN WORLD

2011

Rohrer created *Chain World*, like *A Game for Someone*, in response to a design challenge presented at The Game Developers Conference (GDC): to make a game that could, in itself, become a religion.[1] The game is built on a modified version of the popular *Minecraft* (2009–), an open-ended world-creation game currently enjoying a surge of popularity. Rohrer's world, which draws on classical depictions of the Garden of Eden, is governed by a stringent set of rules. These nine commandments make you, the player, into a kind of mortal god. You are allowed to modify the world you are given, with certain constraints, but you can play only until your avatar dies, at which point you are obligated to pass the game on to another interested party. Significantly, Rohrer produced only one copy, which lives on a thumb drive whose black cover he scratched and distressed so that it resembles an ancient artifact.

While the singular psychological draw of this game was made clear by the controversy that ensued after the first player (after Rohrer) attempted to sell the single copy on eBay, *Chain World* comprises a natural part of Rohrer's larger *oeuvre*.[2] Many of his games rethink the conventions and push the limits that have thus far defined gameplay. In *Chain World*, Rohrer puts pressure on the division between game creator—usually constructed as a kind of god, summoning a virtual world from a vacuum—and the player, who is expected to behave according to a set of received conventions. Here, everyone plays a role on both sides of this division, inhabiting the world while also modifying it for its next Adam or Eve. This prelapsarian setting makes it all the more appropriate that, in the aftermath of its sale, the whereabouts of the game are now unknown. —MM

[1] According to the GDC website, it is the largest and longest-running professional game industry event internationally. See http://www.gdconf.com/aboutgdc/.

[2] For extended discussion of *Chain World* and the attendant controversy, see Jason Fagone, "*Chain World* Videogame Was Supposed to Be a Religion—Not a Holy War," *Wired*, July 15, 2011, www.wired.com/2011/07/mf_chainworld/.

WINDOWS
MAC OS
UNIX

WINDOWS
MAC OS
UNIX

INSIDE A STAR-FILLED SKY

2011

At the beginning of *Inside a Star-filled Sky*, your small, pixelated avatar is situated in the midst of a blocky maze. The maze contains other creatures patrolling their areas and power-ups that increase the capability of your weapon, which can clear your path by firing around corners, after a time delay, or in increasingly complex patterns. But, as the game's key mechanic, the power-ups take effect only when you ascend to the next level, at which point you scale up to become the entirety of the maze you have just conquered. Imagine playing the level as an atom, and then a molecule, and then a piece of DNA, and then a cell...

This game, which builds on many elements of *Transcend* (page 18), branches out in a "nesting doll" structure. As you move up (or out) through the levels, you may return to previous levels to collect different power-ups that make it possible to handle the next tactical situation more efficiently. But just as you zoom in and out of nesting avatars, you may also choose to enter enemies (in order to undermine their power) or even a power-up (to stack ability on top of ability). The game itself has no exact "end"; rather, it spirals in and out of itself, forming a recursive fractal whose variations, according to Rohrer, would take over two millennia of continuous gameplay to exhaust.

In announcing the game, Rohrer related its structure to an origin story derived from Hindu cosmology, in which the world is understood to rest on the back of a giant turtle, which rests on the back of a larger turtle, which rests on the back of a still-larger turtle, *ad infinitum*. This "turtles all the way down" mytheme connects *Inside a Star-filled Sky* with other examples of recursion in key experimental works of art and literature from the last century, ranging from Jorge Luis Borges's 1941 short story "Garden of the Forking Paths" to Robert Smithson's *Yucatan Mirror Displacements (1–9)*, 1969.[1] Rohrer uses the reduplicative process to compose a game that transcends the individual player, creating a digital arena that addresses the scale of the universe itself. —MM

[1] For more on recursion and postmodern theory, see Craig Owens, "Photography 'en abyme,'"
October 5 (Summer 1978): 73-88.

ARROW KEYS TO MOVE
MOUSE TO AIM
MOUSE BUTTON OR SPACE BAR TO SHOOT

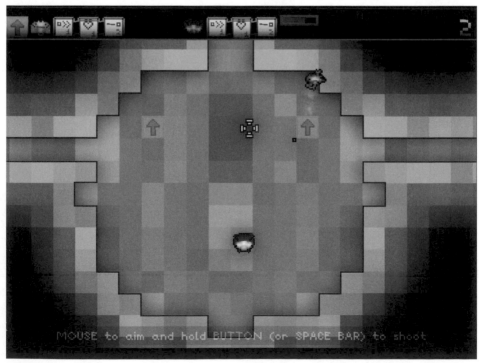

Stills from *Inside a Star-filled Sky*

[That]

[This]

[Score]

[That] is what you are inside. [This] is you.
Rise out higher and higher to increase your [Score].

Hold SHIFT and move MOUSE to enter things.

NINTENDO DS

DIAMOND TRUST OF LONDON

2012

Diamond Trust of London is Rohrer's first game created for the handheld Nintendo DS console. Moreover, it represents the first player-funded Nintendo DS cartridge that was made possible through a Kickstarter campaign. This work is a turn-based strategy game in which two business firms, located in London and Antwerp respectively, compete over diamond acquisition in Angola during the months prior to the United Nations' limited enforcement of rough diamond production and trade controls. The game can be played either against an artificial intelligence (in single-player mode) or against another human being (in two-player mode). Each side must pay agents, distribute them across a map of Angola, direct them to smuggle diamonds back to Europe, and instruct them to bribe opposing agents and UN inspectors. Key points of strategy in the game involve deceiving opponents through movements and payments, managing available resources, and deciding precisely when you want to send the purchased diamonds back to London. After eight rounds of gameplay, the player with the most diamonds wins.

 Diamond Trust of London gives the player the thrill of engaging in black market trades. Though this game is not overtly political or ethically motivated, it is set in 2000, just prior to the United Nations General Assembly Kimberley Process Certification Scheme, which sought to put a stop to the blood diamond trade around the world. Neither celebrating this unregulated era nor directly condemning the association of the diamond trade with warlord-driven conflicts and child labor, the game is focused on the mechanics and complications of transnational trade. In some ways, the game privileges interplayer competition more than it simulates international relations. *Diamond Trust of London* marks a turning point in Rohrer's work, initiating a series of competitive multiplayer games that includes *The Castle Doctrine* and *Cordial Minuet* (pages 80, 84). —PJ

TOUCH SCREEN AND STYLUS WITH ON-SCREEN PROMPTS

A GAME FOR SOMEONE

2013

Rohrer created *A Game for Someone* for the Game Design Challenge at the 2013 Game Developers Conference, whose theme was "Humanity's Last Game." Rohrer designed this board game with the possibility that it would not be played by another human being within the designer's lifetime: "I wanted to make a game that is not for right now, that I will never play… and nobody now living would ever play."[1] Rohrer playtested the game with an artificial intelligence program and then buried it somewhere in the Nevada desert. Though he initially planned not to reveal its location, he distributed over one million unique GPS coordinates, one of which identifies the correct location of the game. In order to create a game that could lay hidden for thousands of years, he constructed the 18-inch board and pieces out of titanium. Little else is known about the game.

A Game for Someone challenges us to imagine an interactive object that is unlikely to be accessed within our lifetime. As a meditation on temporal scales that exceed individual human time, it calls to mind artworks such as On Kawara's ongoing *One Million Years*, begun in 1969, which marks the dates stretching one million years into the past and future of the artwork, and John F. Simon, Jr.'s *Every Icon*, conceived in 1997, which displays all possible icon combinations in a 32-by-32 grid, a task that will take several hundred trillion years to complete. In this sense, the game also belongs on a spectrum with Rohrer's *Inside a Star-filled Sky* (page 68), whose possibilities cannot be exhausted by a single human player. *A Game for Someone* similarly concerns timescales that surpass the individual, and simultaneously opens up forms of collaborative action. Though it is unlikely that one person will search all of the GPS coordinates to find the buried work, a collective effort might make the task conceivable. In this sense, this may be less a game for "someone" than a game for a multitude. —PJ

[1] Michael McWhertor, "Game designer Jason Rohrer designs a game meant to be played 2,000 years from now, hides it in desert," *Polygon*, March 28, 2013, http://www.polygon.com/2013/3/28/4157884/game-designer-jason-rohrer-designs-a-game-meant-to-be-played-2000.

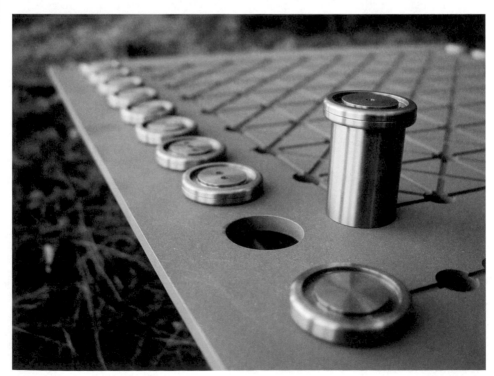

The Burial of *A Game for Someone*

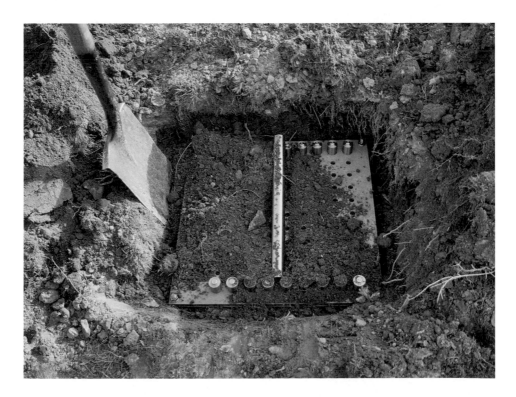

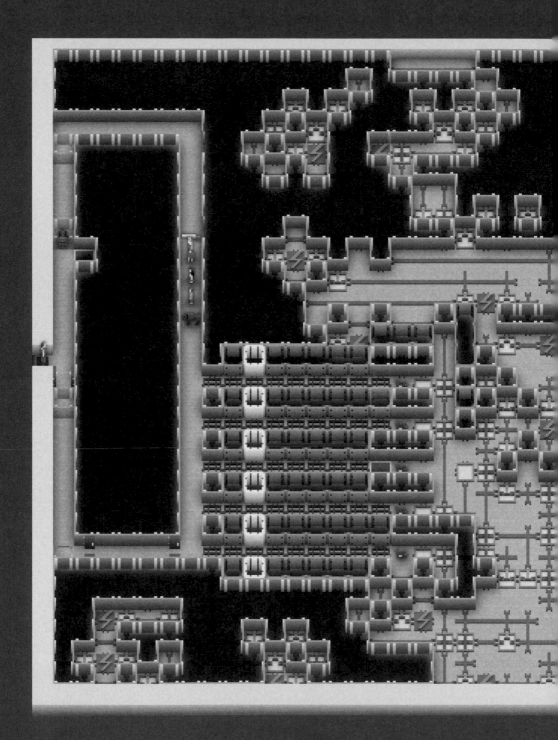

ARROW KEYS TO MOVE
MOUSE AND MOUSE BUTTONS TO SELECT AND PLACE ELEMENTS

THE CASTLE DOCTRINE

2014

The Castle Doctrine, Rohrer's first Massively Multiplayer Online Game (MMOG), draws from the popular genre known as the castle defense game. Most of these games, from *Rampart*, 1990, to *Kingdom Rush*, 2011, require the player to secure and protect a home base from enemy attack. Rohrer's innovative update explores a contemporary world of private property, security, and mutual home invasion. The game proceeds through two simultaneous modes: building one's own home defense and attempting to rob the homes of other players. In the first play mode, you begin with $2,000 to protect family and home, with which you purchase and build objects such as walls, doors, power sources, and traps that might ensnare an invading neighbor. After creating obstacles, you must ensure access to the family's home vault as well as their freedom to leave the house at will. In the second play mode, you invade the homes of other players. Before entering another player's home, you can purchase objects to put in a backpack that will aid you in your invasion. For instance, you can buy saws to cut through walls and drugged meats to fend off attacking pit bulls. When you move through a house (whether a neighbor's or your own), gameplay is turn-based, so pitfalls and traps can move only as many squares as you move. When your avatar dies during a home invasion, you lose all assets and must start over. Successfully robbing a safe in a neighbor's home yields money and backpack items. Unlike Rohrer's other games, *The Castle Doctrine* features a persistent online world without a definite end.

Politically, even in its title, the game evokes the "stand your ground" law—popularly known as "the castle doctrine"—that has been taken up in some form in most U.S. states. Such laws give homeowners the right to self-defense, even shooting to kill, in the case of home invasion. Rohrer's game pushes this legal orientation to its most extreme ends, giving players access to an elaborate array of extremely, even cartoonishly, violent weapons and traps. Instead of celebrating force, however, the game emphasizes the shared precariousness and vulnerability that would accompany a strong castle doctrine. Unlike popular MMOGs with millions of players, such as *World of Warcraft*, 2004, *Final Fantasy XIV*, 2010, and *Guild Wars 2*, 2012, Rohrer's game is utterly unforgiving, adopting a form of "permadeath" that is more common in the difficult genre of single-player "roguelike" games, ranging from the 1980s *Rogue* through roguelike-influenced games such as the 2006 *Dwarf Fortress*. In death, the player loses all resources and achievements and must begin anew. By eliminating any stable sense of security, the game simulates the potentially disastrous results of taking a legal culture of self-defense too far. In place of a well-governed and peaceful political community, this world comes to more closely resemble the seventeenth-century philosopher Thomas Hobbes's "war of all against all." —PJ

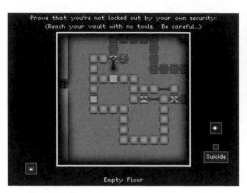

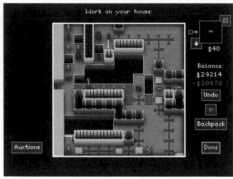

Robbing someone else's house in *The Castle Doctrine*

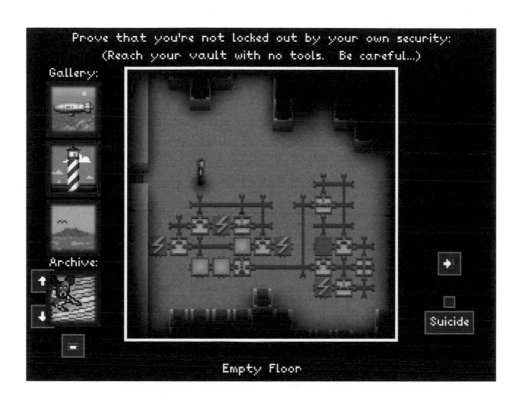

CORDIAL MINUET

2014

Cordial Minuet is Rohrer's only game that requires players to solve a puzzle in order to begin play. After you unravel the anagram of the game's title—and deposit the requisite cash in the game's bank—you are taken to a six-by-six square that has the numbers 1 through 36 randomly dispersed in its cells. You then move through rounds during which you select columns for yourself and rows for your opponents, receiving in points the value of the squares at the intersection of the two selections. You place wagers between rounds, and have one opportunity at the end to place a large bet. The winner is the one with the highest score.

This unusual game reflects Rohrer's deep interest in the cultural history of games. Many of the oldest games, including poker and craps, have roots in both religious practices, such as divination, and the more pedestrian activity of gambling.[1] *Cordial Minuet* plays with this seemingly uncomfortable juxtaposition. The six-by-six square derives from the "magic squares" frequently used in medieval sorcery, in which spells were cast by connecting the numbers that corresponded to the letters of the name of a particular demon. And although *Cordial Minuet* technically does not involve gambling—it is a game of skill rather than chance—the meaning of the game depends on the wagers made with the player's real money. While most games are played for small stakes, one player reportedly made $6,000 over the course of five days.[2] Players are required to literally stake their fortune (in both senses of the word) on the outcome of the game, either reaping a reward or offering a sacrifice to occult forces. —MM

[1] David Schwartz, *Roll the Bones: The History of Gambling* (Las Vegas: Winchester Book, 2013), 1–5, 43–55.

[2] Patrick Klepek, "College Student Found the Perfect Gamer to Win $6,000 From," Kotaku, January 1, 2015, http://kotaku.com/college-student-found-the-perfect-gamer-to-win-6000-fr-1678389587.

Score of 54 (lower right) as the sum of the green highlighted squares

VIDEOGAME EXPERIMENTS: JASON ROHRER INTERVIEWED BY PATRICK JAGODA

Patrick Jagoda: Your videogames are engaging and entertaining but, for me, an even more notable achievement is that your work foregrounds the way that games operate as a technique of analysis and a medium of thought. Games communicate ideas, but they also make concepts sensible, actionable, and transformable through a player's contributions. For example, your games put into play ideas such as perfectionism, relationality, creativity, and private property. How do games allow you to work through a concept differently than other media?

Jason Rohrer: Where linear, fully authored works may leave room for interpretation on the part of the audience, videogames almost always leave room for *completion* on the part of the audience. The inputs and choices made by the players are the final missing ingredients that are necessary for any game to realize its full potential. Without the player, the game is inert. We might compare a playerless game to a car with no gasoline, but it's much more like a car with no driver—parked there, waiting in stasis. With a car, the driving itself is really the main event, and a car can be driven according to many different styles and talents. In the worst case, a horrible driver might even crash the car. The same things

are true regarding the playing of a game.

Thus, where other kinds of work might explore thoughts of various levels of complexity, the playing of a game is almost exclusively made of the stuff of thought: intelligent action and reaction; scientific hypothesis and experimentation. In fact, the players' thoughts are crucial for pushing the experience forward.

When I'm exploring a concept through a game design, I must attempt to predict how players will think, act, and react within the system that I'm constructing. The game's primary mode of function is one where I will stick fresh, uninitiated players into the middle of my constructed system. If the game is successful, their thoughts and actions within the system will resonate with the intended concepts and themes, pushing the system toward even more conceptually appropriate behaviors, in turn triggering more thoughts and actions on the part of the players. The result is like a feedback loop of thinking: my upfront thinking, when I designed the system, braided with the players' real-time, immediate thinking as they play.

PJ: I like the term "experience design" to describe the type of feedback loop and bidirectional process you're elaborating here.

As a game designer, you're creating and defining a rule-based system, but the success of a game ultimately depends on player actions. Player participation is bound, to some degree, by rules and objectives. For example, a *rule* of your arena shooter game *Idealism* [page 42] is that it's turn-based, and thus time passes and enemies move only when you move your avatar through the level. An *objective* of that game is to outmaneuver enemies in order to reach the end of each level. Those elements might limit what you can do in a game. But player participation is also *enabled* by mechanics—the verbs of games, such as "shooting" in an arena shooter or "betting" in a gambling game—that invite choice, skill, and experimentation. The idea of experience design, of course, has a tension built into it, as it depends both on the control of design and the fundamentally uncontrollable range of player experiences.

If we treat a game as a kind of socio-technical experiment, what have you learned most from the people who play your games, including players who approach your games in ways for which you didn't plan? How have those experiments impacted your thinking as a designer?

JR: When I started designing more complex games with more emergent, unpredictable dynamics, playtesting became really important to my development process. Some of my earlier games, like *Passage* [page 26], actually required no playtesting, but I usually tested them at least once on an uninitiated player (usually my spouse, as I quietly watched over her shoulder) before I shipped them. For *Inside a Star-filled Sky* [page 68], an infinite game where I couldn't even visit every possible level, let alone test each one, it became clear that minimal playtesting wasn't going to work. I needed a team of dozens of testing volunteers. That meant I couldn't be watching over their shoulders. How would they describe their experience to me? Via text in an e-mail? If they said that part of the game was tedious and boring, and tried to explain why, could their point of view be trusted and acted on?

I ended up implementing a game recorder for *Star-filled Sky*. Each frame, it would record all player inputs (mouse movements and key presses) into a file. Later, this recording could be sent to me and used to recreate their play session, on my end, exactly as it was played by them. After they sent me their recording, I could effectively "watch over their shoulder" as they played, or as a ghostly version of them played the way that they played.

The discoveries I made about my game through watching these recordings stunned me. A player had claimed the game was tedious, but couldn't explain why. But, oh, look at how they were playing the game! No wonder they thought it was tedious. I had never anticipated that anyone would try playing that way. Who would want to play in such a repetitive, boring way? But sure enough, they were advancing through the game, grinding their way up through the levels using this one weird trick.

What I discovered was that if players could progress in the game via a boring, game breaking method, they would. The game was effectively telling them to play this way. If it's easy and mindless, but within the rules, they'd do it. And then they would complain about the game being boring. This insight led to me patching the *Star-filled Sky's* design to eliminate these grinding possibilities, and the players then said something like, "I don't know what you did, but the game isn't boring anymore." They didn't notice that their boring, grinding exploit had been eliminated. In fact, they didn't like playing that way, or miss playing that way, but they couldn't help playing that way if it was available.

The lesson is this: Don't assume that players are there to have an interesting, meaningful experience with your game. You can't expect them to try to achieve this themselves, as they've signed no contract with you, and the doldrums in the space of your design are their strong attractors. You have to design the game so well that they can't help but to go deep into your mechanics and play well—it has to be the only viable option available to them.

PJ: Both of the games you mentioned, *Passage* and *Inside a Star-filled Sky*, are single-player games. I imagine player behaviors and activities become even trickier with multiplayer games. Your first two-player game was *Crude Oil* in 2008 [page 52]. Since then, you've created several multiplayer games that explore a diverse range of social play. These games depend on asynchronous cooperation (*Between*), coopera- tive storytelling (*Sleep Is Death [Geisterfahrer]*), serial play (*Chain World*), turn-based competition (*Diamond Trust of London*), survival in a massively multiplayer online world (*The Castle Doctrine*), and monetized strategy (*Cordial Minuet*) [pages 34, 62, 66, 72, 80, 84]. Many of these games end up operating as social experiments and platforms as much as games. What modes of thought do multiplayer games make possible that single-player games do not? And what have you learned from designing and observing these types of games?

JR: I've come to see single-player games as a kind of degenerate form. In the long history of games, single-player games were the rare exception, and before the advent of computer- ized games, they were almost unheard of. But here, on our computers, single-player games seem to eclipse everything else.

We might say that we simply enjoy the convenience of computerized opponents—like rubber love dolls, they are always ready, never tire, and don't get mad if you quit halfway through. Some early single-player games did in fact use AI techniques to essentially replace a human opponent—*Pong* is a great example of this, as is computerized chess.

However, very quickly, something else developed and became the dominant form: the true solitaire game, with no possible competitive two-player analogue. In *Pac-Man*, you play against a system of game mechanics, each of which behaves rather simply in isolation, but in concert they create much more complicated strategically and physically challenging situations. The majority of modern solitaire games—including the ones that I've made—are the enduring legacy of games like *Pac-Man*.

As a designer, I eventually ran aground on the limitations of the solitaire game. The challenge in these games stems either from puzzles, which are consumable content, or from reflex challenges, which aren't satisfyingly deep for me as a designer. Some of the very best, most cutting-edge solitaire game designs add randomization to effectively generate an endless stream of novel puzzle and reflex challenge content. Still, devoting a lifetime of study to mastering such a system feels hollow, especially since the quality of the randomly generated content varies.

That's a roundabout way of describing multiplayer games, by discussing what they are not and what weaknesses they do not have. When you have another intelligent, thinking player to play against, the content is endless and of the highest quality—your opponent is motivated to put you in the most confounding, challenging situation possible. Furthermore, what's taking place is much deeper, even if we look beyond the unilateral gameplay experience: a communion between minds through a rich, symbolic language. What you are doing in the game affects another person. Historically, it was the person across the table from you, but with online computer games, it can potentially be a stranger halfway around the world.

PJ: Your account of the exceptional nature of the single-player videogame underscores the central place of the history of games in your work. For example, a history of intersec- tions between gambling and religion in games of chance animates *Cordial Minuet*. Other games, such as your prototype *i45hg* [page 50], were inspired by Go, and *A Game for Someone* [page 76] was (allegedly) inspired by Mancala. Many of your other games are in conversation with a broad range of genres from the history of videogames, including exploration, puzzle, strategy, arena shooter, platformer, tower defense, storytelling, and experimental games. Could you say more about how your knowledge of game history shapes your design practice?

JR: Even though most of my work has involved computer games, I tend to think of myself as a game designer, not just a videogame designer. I imagine myself as a student of a deep, historical tradition, following in the footsteps of a long succession of masters extending back to antiquity. Then I wake up from the daydream and remember that the very notion of a "game designer" is a relatively new one, perhaps not more than a hundred years old. The first real game designer may have predated the advent of electronic games, but not by very long. Certainly electronic games, which aren't very amenable to a folk development process, helped cement the idea that such things could be designed on purpose.

So my imagined long line of historical masters is replaced by a long line of folk games, each of which has mysterious origins. I like to study those origins from time to time in an attempt to situate myself among those historical traditions. And the idea of designing a game that grows legs and becomes a folk game (like basketball) is very attractive to me, though it seems necessary to move away from electronic games entirely if I really care about the longevity of my work. Electronic games that survive longer than ten years become fragile curiosities compared to the unslayable, thousand-headed hydras that poker and *Magic: The Gathering* have become.

PJ: There's certainly a lively and ongoing conversation about videogame preservation as part of a broader concern with conserving digital culture and history. You see private collectors and university libraries contributing to this effort. And now even art museums are part of the process, as people more consistently frame and study digital games as an art form. How do you feel about your game *Passage* ending up in the Museum of Modern Art's permanent collection, alongside *Pac-Man*, *Tetris*, *Dwarf Fortress*, and *Portal*? And how about the Davis Museum's retrospective dedicated to the last decade of your work? Do these contexts influence the way you understand your own work?

JR: I've always been concerned about the transient nature of the videogames that I make. As a designer trying to study the work of those who came before me, I often find this or that seminal game nearly impossible to find and play. As an example that hits closer to home, after only eight years, *Passage* no longer functions on the latest versions of Mac OSX. Even as the original developer, going back to that source code, figuring out what has gone wrong, and rebuilding it is a nontrivial task for me, and it unfortunately remains on the back burner in the face of more pressing concerns, like developing new games. Making all of my code open source will hopefully make it easier for people to access my work in the future.

The efforts of museums and academic institutions in this area are sorely needed, but the task is a difficult one. We are often tempted to resort to emulators as a panacea, but playing old games scaled up on high-resolution LCD monitors often misses important aspects of how the original work was presented and consumed. On blurry CRT televisions in suburban basements, we saw no sharp, square pixels.

So, a proper preservation effort involves obtaining and maintaining original hardware configurations. The obtaining part seems easy enough—eBay brings us instant access to what used to require years of garage-sale hunting. The maintenance, on the other hand, requires electrical engineering skills that are likely out of reach for the existing curatorial personnel.

I understand my games as being seated in the middle of a continuum of work from past to future. I try to study everything that came before me, and I hope that my contributions are appreciated by the creators who will be coming after me. It is deeply gratifying to have this aspect of my work recognized by institutions like MoMA and the Davis Museum.

PJ: Since sometime between 2005 and 2010, there has been a vibrant growth in experimental and art games, an area that is deeply indebted to your work. These games have stretched across

formal and social categories, including Daniel Benmergui's *Today I Die*, 2009, Molleindustria's *Phone Story*, 2011, and Jordan Magnuson's *Freedom Bridge*, 2011. We might also include popularly circulating games such as Jonathan Blow's *Braid*, 2008, and thatgamecompany's *Journey*, 2012. In the second decade of the twenty-first century, we've seen even greater expansions of this approach to videogames— for instance, with queer and feminist games coming from independent developers and amateur designers. Some of those games are Merritt Kopas's *Lim*, 2012, Mattie Brice's *Mainichi*, 2012, Lea Schoenfelder and Peter Lu's *Perfect Woman* (in progress), and a number of Porpentine's gamelike interactive narratives. How do you see the experimental and art games movement developing and how do you understand its significance?

JR: Games with more serious artistic purpose have certainly come a long way in the past ten years. When I first started making games, I wasn't even aware of the notion of an artistic game. I just wanted to make an interesting, novel game that wasn't stuck in the rut of calcified genre conventions. For inspiration when making my first game, *Transcend* [page 18], I looked to the early 1980s golden arcade era and bedroom coders from the mid-1980s— mechanical novelty, not artistic aspiration. After that, as I voraciously read every game design book I could get my hands on, I stumbled upon Raph Koster's book *A Theory of Fun*, 2004. Lo and behold, there was a whole chapter on the artistic potential of videogames. It was a theoretical chapter, discussing more what could be than what was ("Gandhi: The Game?"), and considering possible methods for making artistically meaningful games. I'm not sure who else was inspired by that chapter, but it certainly inspired me, and my next game, *Cultivation* [page 22], took a stab at Kosterian artistic aspiration.

Around that time, a number of other designers were thinking similar thoughts and exploring in their own directions. It seemed to almost be coalescing into a movement as one approach inspired another, but it was still in its infancy, with a lot of false starts and fumbling around. Many of the games from that era, including *Passage*, made a lot of people in the world of videogames very angry. How dare we even call these interactive greeting cards games?

Ten years later, we find the initial "artgame" movement pretty much over, perhaps buried under its own wears-scarf-indoors pretentiousness, and all sorts of splintering alternatives emerging as people try to figure out how to push the envelope next. Notgames? Altgames? Also in the meantime, "indie games" have gone from unheard-of fringe to insanely mainstream (*Minecraft, The Movie*, coming soon), making a handful of people insanely rich in the process. Some of these modern movements seem particularly posed as an alternative to the commercial nature of mainstream independent games, as if to say, "Take that, world, we can still make games that no one wants to pay for." Back in the day, there was no indie success for the punks to rage against.

Even so, some very experimental, groundbreaking stuff has emerged in the realm of commercially successful games. Games like *Papers, Please* and *The Stanley Parable* are way out in the weeds in terms of content and experience, even when compared to various flagship-alternative games movements, yet they both became huge hits.[1] More importantly, they're both artistically sophisticated to the point of not even being embarrassing as examples to show non-gamers. This is a relatively new state of affairs, and a far cry from where we were ten years ago. Millions of people paying money to play experimental, artistic games? That's crazy, man.

PJ: You've already created so many games, from *Transcend* (in 2005) to *Cordial Minuet* (your most recent game as of this interview, released in 2014). Over the last decade, you've created single-player, two-player, and even massively multiplayer online games. You've experimented with numerous genres. You've also taken up a

BY PATRICK JAGODA

range of topics, from mortality to police brutality to conflict diamonds in Angola. Each project seems to go in a new direction.

So, given your earlier comment about the continuum from past and future, how do you imagine the next decade of your work? As an artist, what types of questions (whether formal, technical, social, ethical, or political) do you find most exciting right now?

JR: Ten years in, I'm still trying to figure out how to make really good art at the same time as making a really good game.

I see a level of thematic sophistication in the best modern novels and films that I never see in games, including my own, as hard as I've tried. I'm comparing games to novels and films, and not gallery art, because of their thickness. Gallery art, for the most part, is served by the slice. There's rarely room in those thin slices for much more than a few connected ideas. A novel, film, or game, on the other hand, can contain an entire manifold of interrelated ideas. But I still struggle to make my games as rich and sophisticated thematically as I want them to be. I also struggle with the fact that whatever level of sophistication I can muster is almost never appreciated by the primary audience for my work (game players), and the folks who are perhaps better primed to appreciate those aspects of my work simply don't play games. They may dabble in my games, just to see what all the fuss is about, but they don't play deeply enough to actually pull the whole thing together.

On the other side, I'm still not making games that are as good, as games, as the best examples from our medium. I want to make games that are so deep and nuanced that they are practically bottomless—games that could easily stand up to a whole lifetime of serious study. I still haven't made a basketball or *Magic* or poker. Such games are rich enough, as games, to build whole cultures around. But notice that I didn't list any videogames as prime examples. I still feel that as a medium, videogames are somehow missing something regarding their role as games. We struggle

to create a videogame that is as rich and culturally significant as poker, a game invented by 1800s lowlifes that is played with little more than a standard deck of fifty-two cards. There are whole shelves in the library dedicated to the serious study of poker.

Videogames bring with them a possibility of rich thematics that abstract games like basketball and poker simply cannot have. The open question is whether a deep game and deep thematics can happily exist within the same work. These two elements seem to create a kind of friction against each other, with one often running aground before the other. Either the game was amazing thematically, but I eventually got bored with playing it, or the game was deep enough for serious study, but the thematics eventually wore thin. My goal, over the next ten years, is to smooth over this messy weld and create a game that can stand the test of time both as a game and as a serious work of art, where as you go deeper into the study of playing the game, your understanding of the thematics can continue to grow deeper as well. My recent games *The Castle Doctrine*, 2014, and *Cordial Minuet*, 2014, are my first steps along this particular path.

PJ: Since I've already asked you about your near-future plans, I'll end by asking about the distant future. Some of your projects belong to experiential and time scales that exceed an individual human life. *Inside a Star-filled Sky* offers a structure of worlds within worlds that would take over two thousand years of uninterrupted gameplay to exhaust. And then there's *A Game for Someone*, which may never be played by a human player. I think of this game in conjunction with Margaret Atwood's *Scribbler Moon*—a book that will not be published and read for a hundred years—as part of artist Katie Paterson's Future Library project. Or perhaps in a more medium-specific way, your game shares a fascination with John F. Simon, Jr.'s 1997 *Every Icon*, a piece of software that will take hundreds of trillions of years to execute each possible icon configuration on a 32-by-32 grid. What draws you to this zone beyond human experience?

JASON ROHRER INTERVIEWED

And what might games, as a medium, teach us about that nonhuman realm?

JR: I'm endlessly fascinated with these kinds of projects and thought experiments. *Inside a Star-filled Sky* and *Every Icon* both explore something that we might best describe as the "finite infinite," which occurs as a startling consequence of any discretized system for storing non-discrete information. Clearly there are an infinite number of possible icons, but at the same time, there are a finite number of ways to fill a 32-by-32 grid with 16.8 million possible color values. *Inside a Star-filled Sky* is, for all practical purposes, an infinite game. Yes, someone could reach the top of it (the two-billionth or so level) in a few thousand years, but that completely ignores the twenty or so side branches each step along the way, which are each at least two billion layers deep (and each of those spots along the side branches again branches twenty times, and so on). We've easily reached the point of transcending the capacity of human understanding, and all this comes out of a 2-megabyte computer program that runs just fine on a fifteen-year-old laptop. And the whole thing is clearly finite, not infinite.

A bit of a digression, but my favorite thought experiment from this space involves fixed-length discretized audio. Consider a one-minute clip of monophonic CD-quality audio. There are around 2.6 million 16-bit samples in that minute of audio (44,100 samples per second). That's 42 million bits— quite a few, but still human-scale finite. One minute of CD quality audio is quite an expressive chunk of media. We can't imagine any sound that it couldn't capture and represent as clearly as we could hear it with our own ears—pretty much any possible sound. Clearly, there are an infinite number of possible sounds. Yet there are a finite number of ways to set 42 million bits, and therefore a finite number of minute-long clips of CD-quality audio. When you start to enumerate all of the sounds that are included in this finite collection (your own voice conducting a one-minute interview with each and every human being who ever existed on the planet in each and every language that ever existed and every language that never existed), you quickly run into a kind of mind-boggling absurdity. Forget contemplating the infinite universe. Our finite computers can make us feel plenty small on their own.

Time scale also fascinates me—not just understanding our place as we are dwarfed by a gigantic universe, but trying to grapple with our place in a more palpable transgenerational timeline. There is deep mystery in the past, but we will become part of that mystery for people in the future. Today will eventually be romanticized in a manner similar to how we now romanticize pretty much every era up to and including the 1980s. What is romantic about today? I fail to see anything romantic about it at all. We suffer from a kind of endless myopia about the present. Burying a game in the sand for two thousand years or writing a novel that no one now living will ever read helps to focus our true place in the continuum.

Games are among the oldest human artifacts, and some very old ones, like Go, are still played enthusiastically today. Games transcend language and cultural context better than other creative works, meaning that we can experience them today in much the same way as people long ago experienced them. They help to anchor us in a very long timeline, and serve as heirlooms that we can pass along. And maybe, if we're lucky, we can create a few new heirlooms in our time that will connect us forward into the future. We'll never know whether we succeeded, but we can try.

[1] Lucas Pope, *Papers, Please* (2014), and Davey Wreden, *The Stanley Parable* (2011).